LOWRY

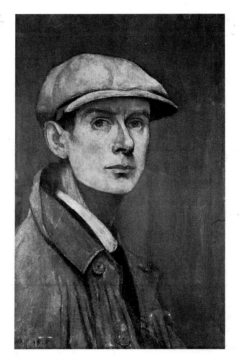

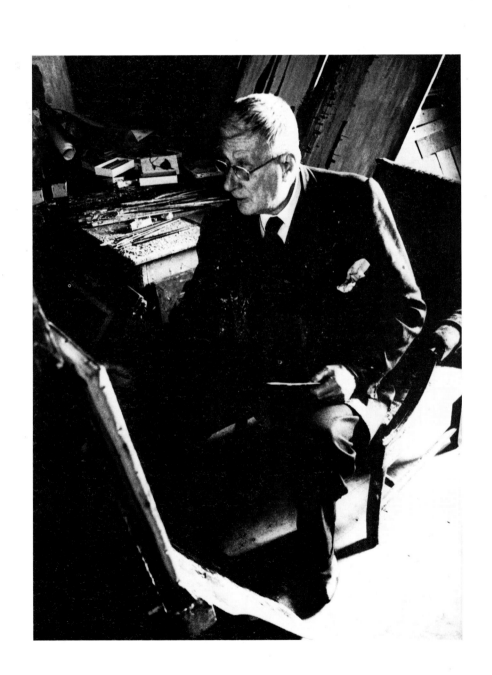

LOWRY

JULIAN SPALDING

THE HERBERT PRESS IN ASSOCIATION WITH THE SOUTH BANK BOARD

First published in Great Britain 1987 by
The Herbert Press Ltd, 46 Northchurch Road, London N1 4EJ
in association with The South Bank Board.

Designer: Pauline Harrison
House Editor: Julia MacKenzie

Printed and bound in Great Britain by BAS Printers Limited,
Over Wallop, Hants.

British Library Cataloguing in Publication Data

Lowry.
 1. Lowry, L. S.—Exhibitions
 I. South Bank Board
 759.2 ND497.L83

ISBN 0-906969-80-8

Exhibition organised by Caroline Collier
Assisted by Claire Hulatt

Cleveland Art Gallery, Middlesbrough 5 December 1987–17 January 1988
Herbert Art Gallery & Museum, Coventry 23 January–28 February 1988
Stoke-on-Trent Art Gallery 5 March–17 April 1988
Royal Albert Memorial Museum, Exeter 23 April–29 May 1988

The exhibition has been sponsored by

✿ **The Royal Bank of Scotland**

A list of Arts Council and South Bank Centre publications,
including all exhibition catalogues, can be obtained from South
Bank Centre Publications, Royal Festival Hall, Belvedere Road,
London SE1 8XX.

The South Bank Centre is administered by The South Bank Board,
a constituent part of the Arts Council of Great Britain.

FRONTISPIECE: The artist in his workroom in the 1960s. Photograph by Tony Evans.
FRONT COVER ILLUSTRATION: Man Lying on a Wall, 1957, City of Salford Art Gallery.
BACK COVER ILLUSTRATION: Sudden Illness, 1920, Martin D. H. Bloom.

CONTENTS

PREFACE

For the centenary of the birth of L. S. Lowry (1887–1976) Salford Art Gallery mounted an immense, comprehensive exhibition of the artist's work. In 1984 the Arts Council was approached by Salford for help with this venture and we have been happy to provide practical help with the organisation of Salford's exhibition, at the same time as planning a touring show, based on the centenary exhibition.

The touring exhibition and this book are intended to extend the somewhat limited view that many people have of the work of an extraordinary and dedicated artist, by giving a sense of the more unfamiliar aspects of his art and by encouraging a careful look at a number of his best paintings and drawings. The exhibition has been devised by Julian Spalding, Director of Manchester City Art Galleries, a sensitive and knowledgeable exponent of Lowry's original contribution to twentieth-century British art.

We should like to thank Michael Leber and Judith Sandling of Salford Art Gallery, with whom we have worked closely on both exhibitions. Salford's collection includes over three hundred and fifty paintings and drawings by Lowry, many of them on permanent display in the Lowry Gallery. We have been able to borrow forty-six of these works for our exhibition. Finally, we are extremely grateful to all the generous owners of Lowry's paintings and drawings, as well as to Mrs Carol Ann Danes and others who have agreed to our reproducing their copyright material in this book.

JOANNA DREW
Director of Exhibitions

CAROLINE COLLIER
Exhibition Organiser

INTRODUCTION

Caroline Collier

'I was hoping that people would get to like these things sooner or later, but I didn't feel I could expect them to buy them. Nobody asked me to paint them.' [1]

It was only when Lowry was an old man that his art became well known and dearly loved by a huge public. He had his first one-man London exhibition just before the Second World War, at the age of fifty-two, and he liked to say that for the first thirty years of his artistic career he was completely ignored. This is not quite accurate; but in the early days, even in the twenties, when he painted some of his most famous pictures, his work was misunderstood and ridiculed. He was admired by a few faithful people and certainly during the 1920s and '30s he exhibited widely in Britain and abroad in mixed exhibitions, although he didn't sell much. Today, just over a decade after his death, he is still the most genuinely popular twentieth-century artist this country has produced. Critical opinion is divided and it always has been, as can be seen from the chronology in this book, which includes extracts from reviews. There are those who think him a genius, and others who consider him superficial, a sentimentalist, a primitive or a sort of gifted 'Sunday Painter' — the label that distressed him most of all. But there have consistently been artists and critics who have responded to the originality and subtlety of Lowry's art, to his strengths as a painter and a draughts-man, and to the way in which in his best works the means of expression and the image are exact equivalents for his mood. It is these qualities that Julian Spalding discusses in the essay which follows this introduction.

There is research still to be done on Lowry. Interest in the myths that surround him — either in refuting or substantiating them — has appeared more attractive than prosaic concerns. There is, for example, doubt about the dating of some of his works. We know that Lowry tended to work on a painting over a number of years, so that several unfinished pictures would be in his studio or 'workroom' at the same time. As there was frequently such a long gap between the inception of paintings and when they were sold, it may be that he continued to add touches to some, or to make more radical changes to others, for years after the dates we are given.

Lowry's paintings and drawings, visionary in their intensity, are curiously complete realisations of states of mind and emotion. It is not surprising that consideration of his art is often bound up with speculation about his life and personality. In the last twenty-five years of his long life he was interviewed so often by journalists and film-makers and he was such a marvellous talker, such a convincing actor, that he was able, by exaggerating certain incidents and concealing others, to control the presentation of his character with remarkable effectiveness. He developed to a high degree the trait which many of us possess, that of keeping various aspects of our lives in compartments which, if not hermetically sealed, at least have the connecting doors shut, and we imagine, well locked.

The stress on personality in relation to Lowry is in many ways ironical. Although he played a part, or many parts, with great charm and conviction, he always seems to have been at pains to emphasise the independence of the artist from the constraints of his everyday life. He did not like to talk about the meaning of his art, preferring to relate humorous stories about the incidents in his paintings, as if the concentration on the narrative content would deflect ill-mannered probing into the privacy of his imaginative and emotional life. The sense of privacy was very important to him. His 'loneliness' did not consist in being friendless – he had a wide circle of friends who were extremely fond of him – but his isolation was deeper and more complete. He hated pomposity and pretension and reacted violently against them, preferring to appear a simpleton and to disguise the complexity of his mind. He was knowledgeable about and deeply affected by music, although he is said to have insisted, with characteristic perversity, on listening to rubbish on the radio when he stayed with friends. He enjoyed the music hall and theatre and saw Pirandello's *Six Characters in Search of an Author* nine times, having first been taken by the young artist Sheila Fell. He said that he stopped reading when his mother died in 1939 but admitted to a liking for Dickens and Donne and for the Restoration dramatists; describing them in a way that illuminates some of the concerns of his art: 'What appeals to me is the beauty of the writing. They give me so much pleasure. They wrote about their times, that certain little world they had, so marvellously and with such style . . . They were artificial, they managed a little world of puppets – pull a string and this one jumps – but they seemed wonderful to me at the time and I think so yet.' Lowry's attitude to artifice and to the power of the artist to control his creations is an interesting one. He was an observer of his 'little world' and always stressed the importance of being 'true to life'; but it is the link between his inner life and the actual world that animates his vision. The use of a wide variety of stylistic devices in his work brings about a new kind of reality. Lowry declared that he valued music most highly and then literature and, with typical self-deprecation, put the visual arts in third place.

Apart from a few revealing letters – and he wasn't very good at answering his correspondence as he grew older and more eccentric – Lowry seems to have written very little. Most of his statements are either recorded on tape or reported speech. There are problems of interpretation, as he was so adept at shaping the tone and content of his responses to satisfy the occasion and, where his remarks are written down by an interviewer, we receive them filtered by the interests and demands of a third party. Lowry's conversations with Maurice Collis, published in *The Discovery of L. S. Lowry* (1951), are, for example, much more consciously poetic than many other statements the artist made. Lowry was sometimes wilfully misleading. The best-known example of deceptiveness is the way he managed to hide the fact that he had worked full time as a rent collector and clerk from the age of fifteen until his retirement at sixty-five, so that when the secret came out after his death it was seen as a revelation. He was frequently inaccurate – apart from his interest in creating an edited version of his past, he was often remembering events of his youth as they seemed to him in retrospect. Besides, he seems to have enjoyed making free with facts, and his quotations, from Oscar Wilde, or Sheridan, or 'The Iron Duke', are frequently bowdlerised and misattributed. However, as will be seen from the quotations from Lowry's statements about his art and life in this book, a voice does come through, that of a sensitive, complex, shrewd, and humorous man. It is not for factual accuracy that we value Lowry; but for the independence and the imaginative truth of his outlook.

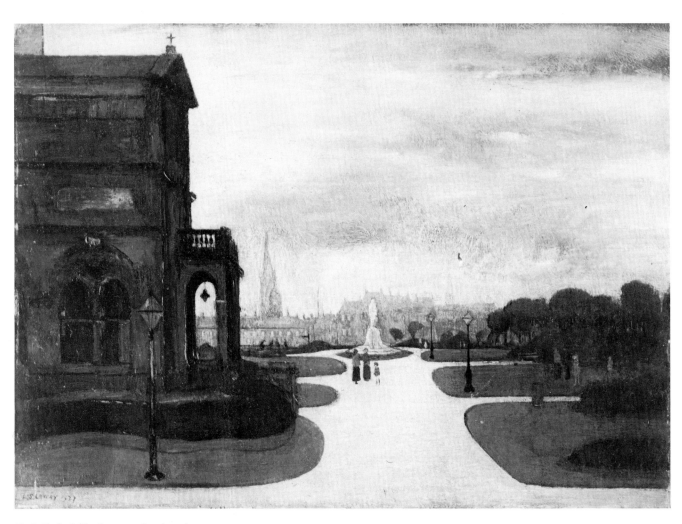

Peel, Park, Salford, 1927, oil on board 35 × 50cm,
City of Salford Art Gallery,
Cat. 27

'The Outlook or Message . . .'
THE ART OF L. S. LOWRY

Julian Spalding

Lowry's popularity has blinded us to the range and subtlety of his art. He has become stereotyped as the painter of mill scenes and matchstick men. But he also painted girls' heads and seascapes, self-portraits and social outcasts. The popular image is only part of the truth. It is not until his work is considered as a whole that the full force of his artistic personality can be felt and the measure of his achievement understood. His personality, his view of life, were complex and paradoxical; his art embraces a great range of feeling, from solemnity to self-deprecation, utter despair to sheer delight. Contrary feelings are often contained in one work; there is usually a note that mocks the seriousness or undermines the humour: a pimple on the hill of a desolate landscape, or a coffin-like building in the middle of a crowd.

The mood is, however, not conveyed just through the subject matter, but by Lowry's treatment of it as well. He told his friend, the painter David Carr: 'There must be innumerable ways of looking at the same aspects of life. A silent street, a building, for instance, can be as effective as a street full of people . . . It is the outlook or message that matters.' He developed a highly original style, or visual language, by means of which he could express his deeply felt experience of life. At first glance his work looks stylistically consistent, instantly recognisable as a Lowry. But when one becomes more familiar with his art and closer to its meaning one discovers a remarkable range of stylistic devices, called up at will rather like a conductor turning from one instrument to another to suit the music's changing mood. That sounds too romantic; a truer analogy for Lowry would be a one-man band, more raucous and popular, but not, at least in his hands, less profound.

What are the different stylistic devices that make up his art? First there are his several quite distinct methods of applying paint: light 'impressionistic' touches strike a note of gaiety; downward strokes convey anguish and despair; horizontal lines, stillness or death; slashing strokes, his anger, frustration, or fierce, manipu-

11

lative sense of fun; firm outlines, his gloomy fatalism; heavily worked impasto, a dream image lifted out of time. Any of these can be brought into play in any picture at any period of his life, though some dominate particular sequences of work or individual images. As with his brushwork, so different colours, including extremes of black and white, different shapes, and, above all, certain compositional arrangements, come to mean specific things for Lowry. He uses these throughout his career, though their meaning changes subtly within each context, reflecting his usually complex amalgam of contradictory moods. By looking at these recurring motifs in Lowry's art, such as his fondness for centralised composition or his use of white, I hope to show how the particular style he developed expresses what he called his 'outlook or message'.

Lowry's art was original in the sense that we talk about someone as being 'an original'. Lowry was exceptionally sure of his sense of direction: at the end of his life he remarked to his friend Monty Bloom, 'All my life I have done what I wanted to do. It's very funny really; isn't it odd?' His clear-sighted, independent stance is nowhere so well stated as in his *Self-Portrait* of 1925 (plate no. 2). Lowry has chosen not to depict himself as an artist with a swashbuckling cravat, as many of his contemporaries would have done, but as a worker — perhaps having just come in from work, with his coat and cap still on. Lowry's art was not a means of escaping his background, but a means of observing the industrial life of his native Salford and Manchester, even when the worker he was observing was himself.

He had a fondness for saying, 'I only paint what I see, you know.' This did not mean that he painted only what was in front of his eyes. Quite the contrary, almost all his paintings were done from his imagination in his workroom (he didn't like to call it a studio). His *Self-Portrait* (plate no. 2), for example, was done almost certainly without a mirror. Like most of his paintings, it was probably a reconstruction of his imagination, not just of what he had remembered but of what he felt about what he had seen. The feeling in this self-portrait is one of clarity and firmness, conveyed by the direct gaze of the eyes and the set of the mouth and by the condensed drawing and the strength of the composition. Lowry has made no attempt to disguise the ungainliness of his features, the big ear and hooked nose; the composition in fact gives some emphasis to them. But there is no caricature here — as he was later to use in his studies of cripples. Nor has his style yet developed its expressionistic potential, the vertical strokes in the background simply establish a plane; they do not express anguish, unlike those in his painting *Head of a Man*, 1938 (plate no. 12).

Head of a Man, 1938, must surely also be a self-portrait, but more of an imaginative distillation than the early painting of 1925. It was painted the year before Lowry's mother died. She had been bedridden since the death of her husband

in 1932, and Lowry was exhausted by nursing her, in addition to his full-time job as a rent collector (which he did until his retirement in 1952) and painting, which he did at nights and at weekends. This picture reads like a reflection one might catch of oneself after a sleepless night, all healthy vigour drained, leaving only strain, tension, physical discomfort and utter despair, and, as Lowry would not have failed to notice, a Desperate Dan stubble and a drunkard's rubicund nose. The self-belittling satire only serves to sharpen the sense of pain.

The style in both these self-portraits has that taut, linear firmness we associate with Lowry when he is expressing his understanding of fate. The younger man's fate was to be both a worker *and* an artist. The assured handling and the strong composition in the earlier picture speak of the seriousness and determination with which Lowry has begun to pursue his career as an artist within the context of his ordinary life. But after his mother's death, Lowry began to see both his everyday existence and his urge to paint in more fatalistic terms.

As a young man, Lowry had a very determined idea of his artistic direction. He studied art at evening class, working as a clerk during the day. He showed no desire to change this state of affairs. His teacher and fellow students all noticed his independence, artistically and socially. James Fitton, a fellow student, left for London to pursue his artistic fortunes in 1922. Lowry stayed. Fitton attributed this to a lack of ambition and a fondness for his mother. In fact, Lowry's steadfast-ness displayed considerable ambition for his art, which he knew was inextricably rooted in his daily life. Lowry lived long enough to see most of the mills of his youth bulldozed away and, as he commented, 'When the industrial scene passed out in reality, it passed out in my mind. I could do it now, but I have no desire to do it now *and that would show*.' His immediate alertness to insincerity of motivation reveals the need for his art to be grounded in meaningful, which, for him, meant everyday, experience. This gave him the strength to say, 'I don't care tuppence for what they do in the London art world. It doesn't *matter* to me. I don't think of it. I don't *know* it. All I am concerned with is doing my own thing in my own way – as well as I can.'

This did not mean that Lowry buried his head in the sand and ignored what other artists were doing. He visited London regularly and saw many shows, and even gave financial help to young artists such as Sheila Fell. His admiration for her work reveals his own motivation: he liked, 'the poetic qualities of a landscape, a mountain landscape, she's lived amongst it, born amongst it, . . . I think she's a very sincere artist.' His earlier paintings show the influence of his teacher, Adolphe Valette (see plate no. 9), the French artist who saw Manchester with the eyes of an Impressionist. Many of Lowry's pictures are also close in sympathy

and style to the work of other English Impressionists, particularly the group known as the Camden Town School. Malcolm Drummond's *St James's Park*, 1921 (plate no. 8), is nearly a Lowry (e.g., *A Street Scene – St Simon's Church*, 1928, plate no. 7), except that Lowry dramatises the scene by contrasting the animated figures with the black mass of the church. He used a widespread artistic language but adapted it to his own ends.

Lowry's early industrial scenes of the twenties are the nearest his work comes to being part of a school. For the rest, his style is out on a limb. This does not mean, however, that Lowry's work does not share in the *Zeitgeist* – the spirit of the age. His agonised *Head of a Man*, 1938 (plate no. 12), is remarkably close in feeling to the heads of Francis Bacon (see plate no. 13), which themselves spring from a figurative expressionism that was such a powerful ingredient in British art immediately before and after the Second World War. Lowry's *Head of a Man* is not stylistically indebted to neo-romantic artists such as Graham Sutherland, who spearheaded this school, though Lowry would have been well aware of their art. His image shares their spikey expressionism but is unique, startling even now for its *lack* of taste, its ferocious naivety. The only artistic debt it seems to owe is to cartoons; the shining red nose, in particular, could have sprung direct from a comic seaside postcard.

There are two elements at work here: Lowry's instinctive distrust of the art world (anything aesthetic and tasteful was positively to be avoided) and his sense of humour that undercut pomposity or pretentiousness. 'Most of my help', he said, 'has come from people who don't paint. Friends come in and say, "What are you up to, old chap?" and I show them and ask them what is wrong with it. They tell me. "Mind you," they say, "I know nothing about it." And then you get people who paint, staring at it for a long time and can't give you an answer.' As he once said, 'Getting to the truth in painting is getting near to life.' Constable had the same attitude; when he started to paint he tried to forget he had ever seen a painter. Both became revolutionary painters by turning their backs on art.

There is something wilful about Lowry's revolution. His art became so anti-aesthetic that it is tempting to think that he deliberately rejected the values of the London art world because they had rejected him. There may be an element of truth in this, for though he had occasional success, he sold little and remained an object of fun until well after the Second World War. But this rejection must in some ways have confirmed him in his independent stance. As fame came to him for his industrial scenes, so he painted fewer and fewer of them and began to concentrate on single figures, singularly unappealing. Like Constable, who welcomed imitators because they showed him what *not* to do, Lowry welcomed appreciation because it encouraged him to explore further, beyond the familiar

and successful. He said of his single figures, 'I think this is my best period. I think I am saying more, going deeper into life than I did.'

Lowry's early paintings were more aesthetic, more 'artistically' arranged than his later works. Many are organised according to the laws of the golden section – a means of dividing up a rectangle into areas that are of unequal size but balance each other proportionately. *Sudden Illness*, 1920 (plate no. 35), is painted according to these laws. The feeling of a tense moment of stillness has been created by Lowry's control of the composition. A small crowd has gathered on an exposed strip of road. There is hardly any warmth in the picture, except for a lingering golden tint in the sky. The cold air breathes on the faces of the strangers who stand round the collapsed man who is isolated from them by his illness. The thought that the sick man might die crosses one's mind. Lowry has placed him at one intersection of the golden section – one of the most fixed positions in the composition. At the complementary intersection of the golden mean, in the top-left quadrant of the picture, Lowry has painted smoke pouring from a chimney. The black, fallen figure is balanced by the gently rising drift of smoke.

The same compositional device is used in *The Funeral*, 1920 (plate no. 37). The light peak of the tower is the exact, inverse correspondent to the little horizontal black line of the grave at the centre of the cluster of figures. The picture is harmonious but bleak, about death in life. There is a suggestion of hope in the aspiring tower of the church, but this is balanced by the black pit of the grave. Lowry was not a religious man, though he later maintained, 'There must *be* a God. I can't believe it's all waste.' The play of life and death, like two sides of a coin, is one of the main themes of Lowry's art, though he rarely treats it so mournfully or lyrically again.

To the right of the group in *Sudden Illness* a man has turned to face us. He has seen Lowry looking at the scene. In Lowry's early work, he tends to be the observer unobserved. On his daily round as a rent collector he saw many subjects for his paintings. In his pictures a line usually runs close to and parallel with the bottom edge. His figures trudge backwards and forwards along this line, drawn by their fate (see plate no. 37) rather like those little cut-out figures on rods in Pollock's Toy Theatres (penny plain and tuppence coloured). 'I see lots of people everywhere, myself,' he once commented, 'one lot going one way and another lot going the opposite way as a rule. I sometimes wish I didn't see folk everywhere.' In everyday life we ignore, perhaps for our own sanity, the numbers around us. But you have only to stop for a moment in a busy high street, detach yourself from the scene and look, to discover all the ingredients of a Lowry picture: idlers standing around, suitcase salesmen, stray dogs, people sitting down and,

everywhere, small heads and long legs, legs scissoring along in repeating patterns, like iron filings springing to obey the force of a hidden magnet. Individuals are subsumed into a pattern of activity. This is the secret of Lowry's crowd scenes. It is not the individuals, though each has character, but the way they relate to each other, echo or counteract each other's shapes to build up a rhythmic pattern that creates the vitality of his scenes.

These massed crowd scenes, viewed from a distance for their overall effect, are Lowry's idiosyncratic development of Impressionism. His early drawing of Peel Park (plate no. 27) and the subsequent painting (plate no. 28) show Lowry using the light touches and broken brushwork to give an overall impression. Not only the individual figures but the buildings in the distance become indistinct. This is a technique that Lowry used intermittently throughout his life. It tends to be associated with feelings of exuberance and sheer delight, that momentarily veil his brooding awareness of the continuing presence of death. *Whit Week Procession at Swinton*, 1921 (plate no. 25), and *Ebbw Vale*, 1960 (plate no. 26), are early and late examples of this technique when his brushwork dances over the surface, breaking up the containing forms that tie the people and the buildings to their destiny. South Wales was a late discovery for him. His friend Monty Bloom took him there, and he was excited to discover a survival of the industrial scene he thought had gone for ever. His exuberance perhaps accounts for his use of an impressionistic technique, though as he worked on the theme, brooding qualities began to emerge.

One of his most truly impressionistic works was painted purely at his mother's request, *Sailing Boats*, 1930 (plate no. 24). His mother disliked his art, which she thought ugly. Once he asked her, 'What would you *like* me to paint?' 'Little boats at Lytham' — where they used to go on family holidays — was the reply. This picture is the result, and it stands out in Lowry's art, exceptional for its exuberantly free brushwork. There is a slight sense of strain in it, particularly in the rather strident colours, as if the subject matter and the treatment went against the grain.

Despite the power which his mother had over him, and to which all his close friends of the thirties attest, her dislike of his work could not deflect him from his determined direction. His art stood independent of her approval. Her death in 1939, however, almost stopped him painting. The hopelessness he felt is expressed as a premonition in his *Head of a Man* of 1938 (plate no. 12). After she died, he said, 'My life altered utterly and completely.' He stopped painting for three months. 'I can't say what kept me on, but something did. Isn't there at the beginning of *The Pickwick Papers* a cab driver who had a cab with enormous wheels and when he once starts off, he can't stop? Well I'm like that. I can't stop. It's a pitiable story.' In a sense, *The Carriage*, 1962 (plate no. 21), is a late self-portrait

– the artist as cab driver, unable to stop, disappearing into nothingness.

It is interesting to compare this picture with *The Funeral* (plate no. 37). There is no off-centre composition or balance of buildings and people, or of death with the bustle of life. The image is now central, much starker. There are no soft tones to alleviate the severe white and black. The only prop – a simplified line of railings, was one of Lowry's favourite motifs; he was fond of commenting, 'Do you know I never had a family – all I had round me was the garden fence.' How different this is from Stanley Spencer's use of the railings and garden walls of Cookham village, behind which, as a child, he imagined the magical re-enactment of biblical scenes (see plate no. 22). There was no paradisal comfort for Lowry, hardly any greenery and virtually no flowers. Nevertheless, both *The Funeral* and *The Carriage* have humanity; in the earlier painting it finds its expression in a mournful sympathy, in the latter, in a sense of the ridiculous.

The crucial change in his art came with his mother's death, or just before, during her protracted illness. Increasingly, towards the end of his life, his friends sensed his desolation, which occasionally broke the surface. 'Strange thing, life. Why are we *doing* it? What's the point of the whole thing? Why? What of it? I can't get used to it. Why? Why? Can you answer me? What's the purpose of it all? Everywhere you turn is suffering . . . and . . . it gets worse.' 'All this waste' found expression in his great *Lake Landscape* of 1950 (plate no. 17), one of a series of large canvases he produced when he began painting in earnest again after the Second World War. There are no impressionist touches here: the hillsides are modulated carefully through moonlight tones of bluey greys as they recede into the distance, eventually merging with the horizon of the bright white sea that seems to be slowly rising to flood the land. Lowry had a thought at the end of his life about the tide. 'What if it doesn't turn? What if it goes on coming in and coming in and coming in.' During the fifties he painted a series of empty seascapes (plate no. 44). They are not still; there is movement in them, made up of slightly arching horizontal lines, the slow, inevitable swell of a rising sea. Just like the carriage, fate drives it. Lowry said of the sea, 'It's all there. It's all in the sea. The battle of life is there. And fate. And the inevitability of it all. And the purpose', though the purpose alluded him.

Towards the end of his life, Lowry painted a marvellous, though tiny, picture called *Waiting for the Tide, South Shields*, 1967 (plate no. 18). The same thick white sea and sky are there, but on the barely discernible horizon that separates the elements lies a barge that is at once comic and sad. Though it is obviously a boat, it looks like a man lying down. The analogy becomes obvious when one compares it with *Man Lying on a Wall*, 1957 (plate no. 51). The prow is his

up-turned feet, the bridge, his head. He is even smoking a cigarette too, and the blunt funnel serves for a nose. The mast at the front is an echo of the chimneys. *Waiting for the Tide* is Lowry waiting for death. In *Man Lying on a Wall* Lowry has put his initials on his briefcase, just as he once put his initials on a coffin in a picture by his friend, the Reverend Geoffrey Bennett.

If one looks even further back and compares *Man Lying on a Wall* with *The Funeral* (plate no. 37), it is startling to find Lowry using the same visual devices. Instead of the fence, there is a curb, to separate the viewer from the scene. Both pictures are divided by a horizon. The black body of the chapel is shifted across from one side to become the figure of a man. The spire is changed into a clock tower and the golden mean we observed before is used again, though this time the spire balances not the grave but, making a visual pun, the man's umbrella, pointing down. L.S.L. is on his way out. Lowry claimed to have seen a man lying down to have a rest which gave him the idea for this picture. One thing he must have liked about it was the sheer cheek of it; you're supposed to be upright if you're out in the street.

Horizontals and verticals are a dominant feature of Lowry's art: tall mills and chimneys rise up from the flat streets, and, at the point of intersection, small sloping figures scurry along (plate no. 11). In those increasingly gloomy years when Lowry was nursing his mother, his compositions became more centralised (on himself), and, as they did so, the horizontal and vertical movements acquired a new personal significance. In *Head of a Man* (plate no. 12) the unnatural horizontal lines above the eyes are crucial to the whole effect. They make the eyes stare unbearably and draw attention to the blue in them, a blue that also streaks vertically down the background of the picture. In the same year, Lowry painted, or rather finished painting (because it took him several years to complete), one of his most extraordinary pictures, *St John's Church, Manchester* (plate no. 42).

The picture is as severely symmetrical as his *Head of a Man*; it is, in its way, a portrait as well. The absorbing, brooding quality of this work lies in the subtle brushwork. The sky, in particular, is finished with light, flickering strokes that link this picture to Lowry's most impressionist paintings. Joy and delight are there, on the surface, but one senses a darker mood underneath. The paint is elaborately worked, built up layer on layer and, when one gets close to the picture and absorbed in its atmosphere, one realises that it is the directional movements in the different layers of paint that create the picture's complex mood. As one watches, the sky appears to descend as the tower rises, while the horizontal brush-marks on the church's facade re-assert the building's weighty presence in the misty atmosphere. The flanking houses are painted with downward strokes, and the road recedes with horizontal strokes. Expansion and contraction, ascent and descent, light and dark, stillness and turbulence, are embraced in one composition

to create an image of serenity during one of the most disturbed periods of Lowry's life.

Central images are a recurring motif in Lowry's art; they can usually be interpreted as self-portraits: Lowry confronting an image of himself in various guises – as a bearded lady, a monument in a crowd, or a carriage going over a hill. One of his earliest drawings is *Boy in a Schoolcap*, 1912 (plate no. 53). The treatment of movement in the drawing, the balancing of vertical and diagonal directional planes, is a remarkable anticipation of his later work. The boy's centrality suggests that this too is a self-portrait. As in his *Self-Portrait* of 1925 (plate no. 2), Lowry chooses to show himself not as an artist, but dressed for his role in the world, here a schoolboy.

After his mother's death, the central imagery becomes common. He painted a series of idealised images of women (*Portrait of Ann*, 1957, plate no. 14). They are not strictly portraits though some are based on a series of young girls, usually called Ann, whom he befriended in the later years of his life, and whose presence helped him re-live an earlier experience, perhaps of a woman he had loved long before, or possibly a memory of his mother in her younger days.

Lowry was fascinated, and repelled, by Rossetti's heavy-lidded and -lipped portraits of women, and he collected several of them when he could (see plate no. 15). He said of them, 'They are not real women. They are dreams. He [Rossetti] used them for something in his mind caused, in my opinion, by the death of his wife. I may be quite wrong there, but significantly they all came after the death of his wife.' That phrase, 'something in his mind', sounds like Lowry talking about himself, and perhaps it reveals his own motive for painting these strange semi-portraits. They are thickly painted, and are fixed, like a mask, by a precise outline. There is no break in the geometry, and unusual for Lowry's art, they do not return your stare; they do not answer back. Like icons, they remain transfixed, in an ethereal atmosphere, but of white, not gold.

During his mother's long illness, Lowry experienced depths of despair that later found expression in the bleak wastes of his lake landscapes and seascapes. A rising tide of white meets a lowering white sky, divided by a hair's-breadth horizontal line that fades to nothing in the centre, creating the image of an immense void. This white, purer and fiercer than before the Second World War, becomes the dominant environment of almost all Lowry's later work. The white is not air, it is certainly not snow, but an imaginative ether in which Lowry isolates the objects under his gaze rather as if he had taken things out of life and put them in an operating theatre. Once there, they are treated with a similar severity.

Lowry once said he couldn't draw a cat, except by doing a dog first and

decapitating it. Is the animal at the bottom right in *The Cripples*, 1949 (plate no. 62), a dog or a re-capitated cat? In this painting, one can't help feeling that Lowry personally has truncated a leg, blackened an eye or smashed a jaw. There is a slapstick element in the brushwork and the drawing of his later work. When asked why he was so fascinated by cripples, he replied, because 'they are so comic'. In his desolate world, he seems to have felt that these unfortunates had been invigorated by their disadvantage. He claimed, when accused of being cruel, that these people were probably happier than he was. Yet at the same time he said, 'They are real people, sad people. I'm attracted to sadness, and there are some very sad things. I feel *like* them.' The man in *Courting*, 1955 (plate no. 59), looks distinctly like a fierce self-caricature; the pastels dig harshly into the surface of the paper, with slashing strokes and abruptly broken lines, to create his beaked nose and fixed grimace and that blunt fist resting on knees that create such a barrier between himself and the girl.

Lowry's drawing style had never been hesitant. His earliest mature drawings, like *View from a Window of the Royal Technical College, Salford*, 1924 (plate no. 36), show an enjoyment in using the full range of the medium from the lightest, most delicate, touch to the darkest, fiercest black. Such dramatic contrasts are, if anything, intensified in his late drawings such as *Family Group*, 1967 (plate no. 74). Instead of a chimney and a misty townscape enlivened with figures, you have a humped mass of body on two columnar legs with the outline of a face peeping round. One has the impression that the lively, curious expression has been created almost casually by stray lines and smudges which coalesce into a barely feasible physiognomy. The dark mass, from which this face peeps, is pre-saged in Lowry's earliest work. A similar shawled, bowed figure can be seen in many of his drawings, such as *The Spinner's Arms*, c.1920 (plate no. 39). The hunched form and tightly buttoned jacket of the man standing next to the shawled woman is also echoed later in *The Tramp, St Peter's Square*, 1971 (plate no. 69).

Lowry's art consists of a continual reworking of certain shapes or, rather, visual ideas, which clearly have a personal significance for him, though one which it is extremely difficult to fathom. Just how personal this is can be guessed from those extraordinary late drawings of girls with bows (plate nos 54, 77) which with their starched collars echo Lowry's early portrait, *Boy in a Schoolcap*, 1912 (plate no. 53). The sensation of stiff clothes being removed to reveal bare breasts finds an echo in the famous lines from Philip Larkin's poem *Annus Mirabilis*:

> So life was never better than in nineteen sixty three
> (though just too late for me)
> between the end of the Chatterly ban
> And the Beatles' first LP.

Larkin cut a similar figure to Lowry, as an ungainly, elderly, Northern bachelor who lived to see the sexual freedom of the sixties but himself remained bound by earlier conventions.

Containing shapes were vital for Lowry: he drew outlines whether with a crayon or brush, with exceptional energy and force. His figures are trapped in their own fate. But they invariably fight back, like the face that peers out of the lumpen mass in *Family Group* (plate no. 74) or the hand that protrudes from under the black bent form of the beggar (plate no. 20). There is something comic about this, comic because of the cheeky assertion despite handicap and oppression.

The sense of humour increased in Lowry, as his art sought out more keenly the sensations of misery and the grotesque. 'I look upon human beings', he wrote, 'as automatons: to see them eating, to see them running to catch a train, is funny beyond belief . . . because they all think they can do what they want . . . and they can't, you know. They are not free. No one is.' In his earliest paintings and drawings like *The Spinner's Arms*, c. 1920 (plate no. 39) Lowry's figures are usually occupied doing something or standing around preoccupied. In his last works, such as *Family Group* (plate no. 74), they are busy, too, usually looking curiously at something, and because they are absorbed and forgetful of themselves they themselves become curious to look at. Even some of the icebergs in *In the Sea* (plate no. 71) seem to be looking about in a lost sort of way while others drift along with the tide. In one ludicrous drawing (plate no. 81), a man is swallowed by a shark. He looks furious but there is nothing much he can do about it. The figure drowning reminds one of a famous couplet by Stevie Smith: 'I was much too far out all my life / And not waving but drowning.' Stevie Smith shared some affinity with Lowry in her private life and in her art. Neither married. Both had watched their mothers die and later became fascinated by death, and drew imagery from the sea. Both did routine jobs and lived unfashionable lives in unfashionable places. Both moulded their style out of a mixture of the sophisticated and the vernacular, with one foot in the extraordinary and another in the ordinary. Both had an impish sense of fun.

Lowry increasingly jokes at the end of his life. Having tried to stop painting after his mother died, and failed, he could now see the funny side of both life and art. As a man and as an artist he was like the cab driver who couldn't stop – 'a pitiable story' – until the tide rose, or he was snapped up by a shark. Describing his feelings on waking up during his last years, he would say, 'I'll wake up and nobody is there and it is very quiet and very still and – I don't know – sometimes my mother is there with me. I don't see her, but I feel her presence and I hear her telling me, as she always did: "Get up, Laurie, get up." And I know, from experience, that if I stick my feet out of bed, shove my legs right out, it'll be all right. And that's what I do. And it *is* all right.' He used to illustrate this story

by suddenly sticking out his long straight legs. That gesture is there in his painting. In the silent whiteness, a girl springs forward and shouts (plate no. 76), a tramp grabs at something in a bin (plate no. 69), a beggar bends his head and thrusts out his hand (plate no. 20), or a boy suddenly turns round to grin at the man who has been following them (*The Family*, 1964, plate no. 78). In these late paintings and drawings, Lowry is not seeking sympathy. He is looking for a reaction, a sign of life, a kick against the inevitable. He kept telling his friend, the painter Harold Riley, 'the thing about painting is that there should be no sentiment.' Life was too hard to be sweet and it was not in his nature to soften what he was fond of calling 'The Battle of Life'. In his last years, he felt he was 'going deeper into life', and, as he put it, 'getting to the truth in painting'. His language had become starker, the contrasts stronger. And though many of his late pictures are small, they have a bright, cheeky presence that kicks out against the odds.

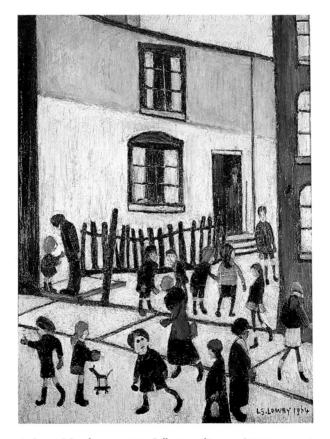

A Court, Manchester, 1964 Collection of L. A. and D. C. Ives

THE PAINTINGS
AND DRAWINGS

FROM EARLY TO LATE WORK

This section includes comparative illustrations of paintings by other artists.

'Before 1915 I did not know how to express my mood. My figures then were naturally drawn.' [2]

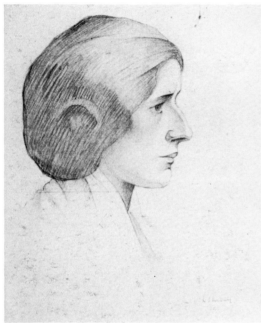

1 Study of a Woman's Head 1914
pencil on paper 44.1 × 35.5cm
CITY OF SALFORD ART GALLERY
Cat. 7

'An artist can't produce great art unless he has a philosophy. A man can't say something unless he has something to say. He can see things that a camera cannot see. A camera is a very wonderful piece of mechanism but an artist has his emotions, he has his feelings and he puts those feelings into any work he is doing. If he feels strongly for his subject he will do it the better.' [3]

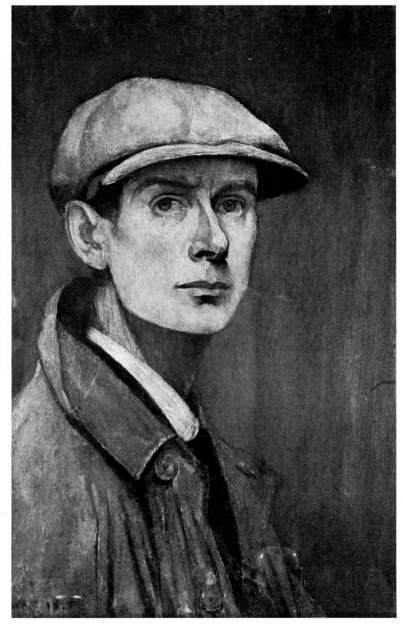

2 Self-Portrait 1925 (detail)
oil on board 57.2 × 47.2cm
CITY OF SALFORD ART GALLERY
Cat. 25

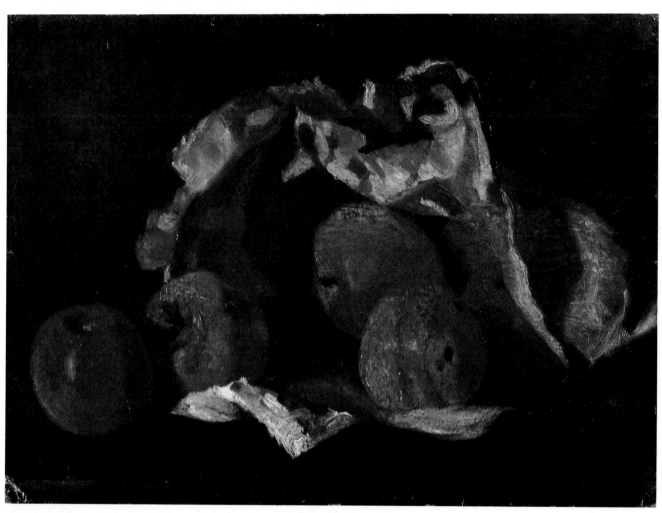

3 Still Life 1906
oil on canvas board 23.5 × 33.5cm
CITY OF SALFORD ART GALLERY
Cat. 1

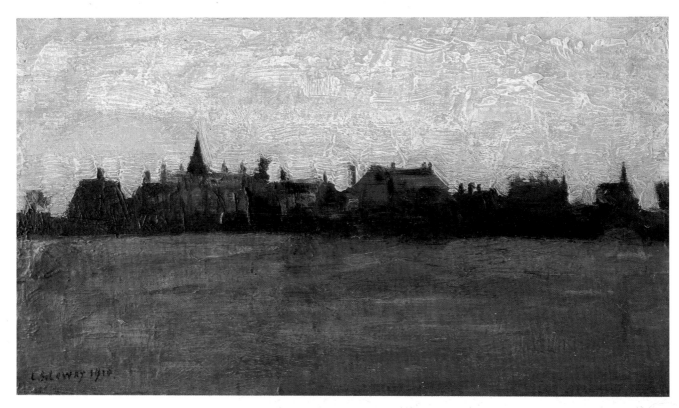

4 Clifton Junction – Morning 1910
oil on board 20.2 × 34.8cm
CITY OF SALFORD ART GALLERY
Cat. 2

5 Clifton Junction – Evening 1910
oil on board 19 × 35.5cm
CITY OF SALFORD ART GALLERY
Cat. 3

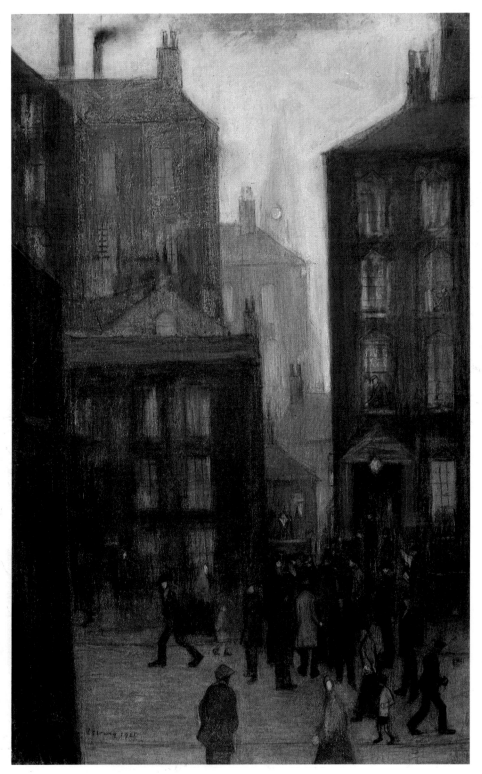

'To my loss, country lanes have been foreign to me somewhat for quite a while past – for alas my recreation seems to have developed into drifting amongst all the back streets, etc., I can come across. I don't know what your Naturalistic Nature will think of an outlook like that!'[4]

6 The Lodging House 1921
pastel on paper 50.1 × 32.6cm
CITY OF SALFORD ART GALLERY
Cat. 17

'I wanted to paint myself into what absorbed me. Natural figures would have broken the spell of it, so I made them half unreal. Some critics have said that I turned my figures into puppets, as if my aim were to hint at the hard economic necessity that drove them. To say the truth, I was not thinking very much about the people. I did not care for them the way a reformer does. They were part of a private beauty that haunted me. I loved them and the houses in the same way, as part of a vision. Had I drawn them as they are, it would not have looked like a vision.' [5]

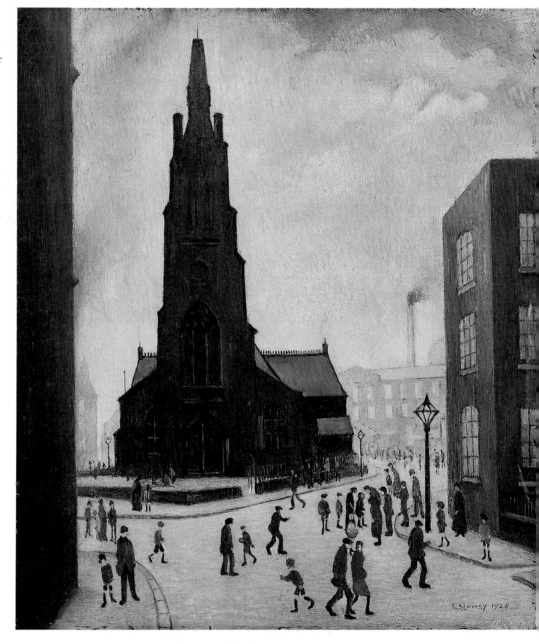

7 A Street Scene – St Simon's Church 1928
oil on board 43.8 × 38cm
CITY OF SALFORD ART GALLERY
Cat. 28

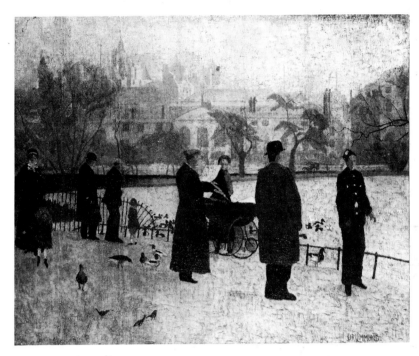

8 Malcolm Drummond
St James's Park 1921
oil on canvas 72.5 × 90cm
SOUTHAMPTON CITY ART GALLERY

9 Adolphe Valette
Albert Square, Manchester 1910
oil on jute 152 × 114cm
CITY OF MANCHESTER ART GALLERIES

*'My whole happiness and unhappiness were that my view was like nobody else's.
Had it been like, I should not have been lonely; but had I not been lonely, I should not have seen what I did.'*[6]

10 Coming from the Mill 1917–18
pastel on paper 43.7 × 56.1cm
CITY OF SALFORD ART GALLERY
Cat. 9

I see lots of people everywhere, myself, one lot going one way and the other lot going the opposite way as a rule. I sometimes wish I didn't see folk everywhere.' [7]

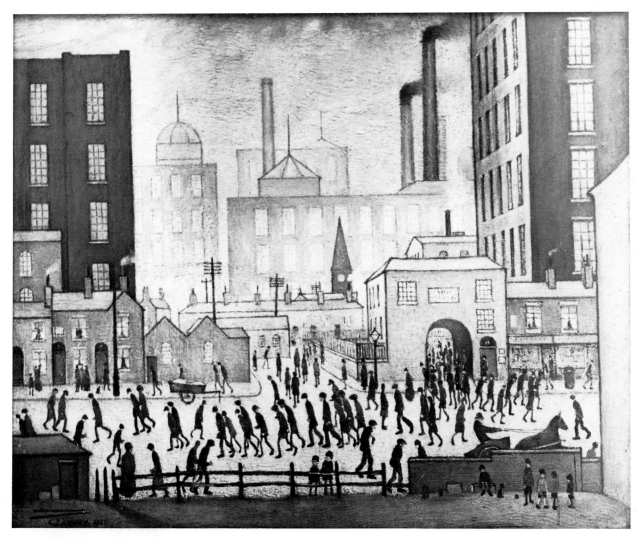

11 Coming from the Mill 1930
oil on canvas 42 × 52cm
CITY OF SALFORD ART GALLERY
Cat. 29

'The buildings were there and I was fascinated by the buildings. I had never seen anything like them before. But I was fascinated by the people who lived and worked in them. A country landscape is fine without people, but an industrial set without people is an empty shell. A street is not a street without people . . . it is as dead as mutton. It had to be a combination of the two – the mills and the people – and the composition was incidental to the people. I intend the railways, the factories, the mills to be a background.' [8]

31

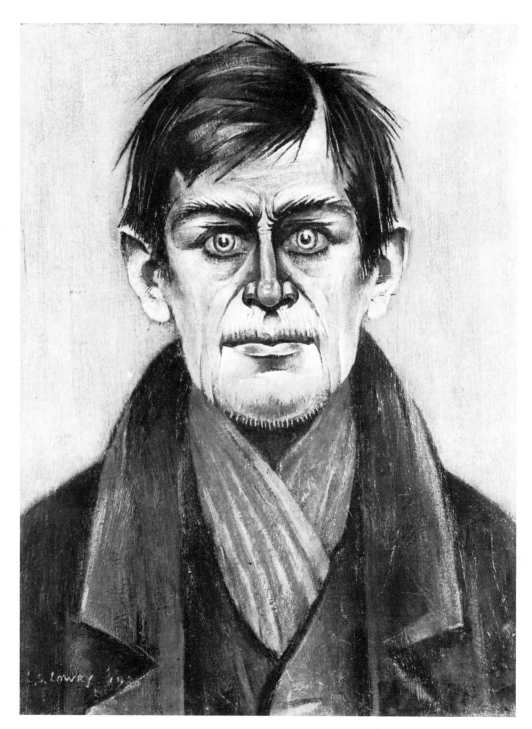

12 Head of a Man 1938
oil on canvas 50.7 × 41cm
CITY OF SALFORD ART GALLERY
Cat. 34

'I was simply letting off steam. My mother was bedfast. I started a big self-portrait. Well, it started as a self-portrait. I thought, "What's the use of it? I don't want it and nobody else will." I turned it into a grotesque head. I'm glad I did it. I like it better than a self-portrait. I seemed to want to make it as grotesque as possible. All the paintings of that period were done under stress and tension and they were all based on myself. In all those heads of the late thirties I was trying to make them as grim as possible. I reflected myself in those pictures.' [9]

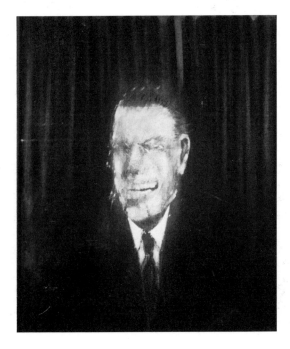

13 Francis Bacon
left-hand panel from
Three Studies of the Human Head 1953
oil on canvas 24 × 20cm (panel)
PRIVATE COLLECTION

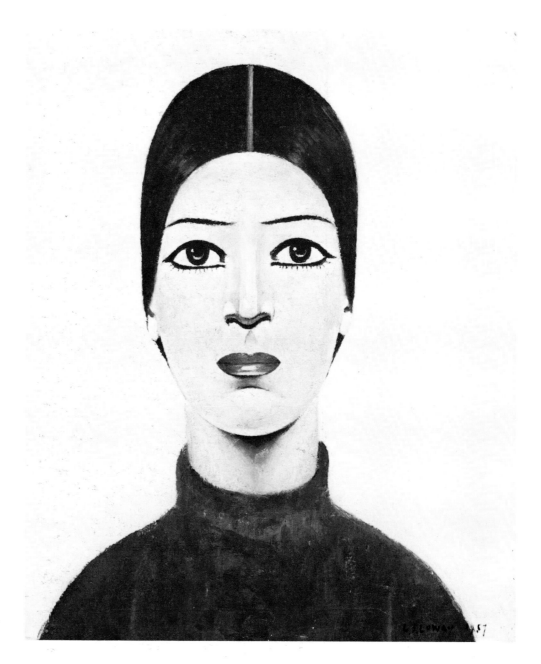

14 Portrait of Ann 1957
oil on board 38.6 × 33.3cm
CITY OF SALFORD ART GALLERY
Cat. 51

'They are not real women. They are dreams. He [Rossetti] used them for something in his mind.' [10]

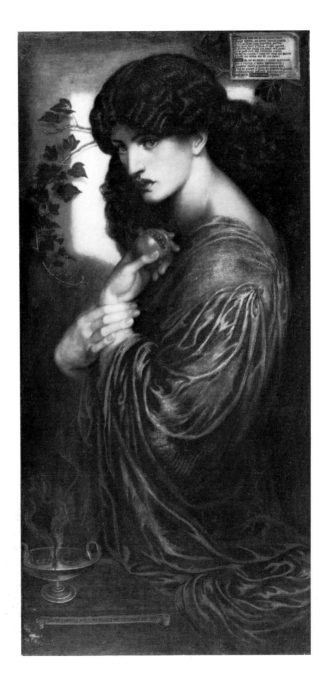

15 Dante Gabriel Rossetti
Proserpine 1873 & 1877
oil on canvas 119.5 × 57.8cm
THE LOWRY ESTATE (ON LOAN TO CITY
OF MANCHESTER ART GALLERIES)

'Strange thing, life. Why are we doing it? What's the point of the whole thing? Why? What of it? I can't get used to it. Why, why? Can you answer me? What's the purpose of it all? Everywhere you turn is suffering. Why? God only knows I don't. Why all the fuss and flurry? Can you tell me?' [11]

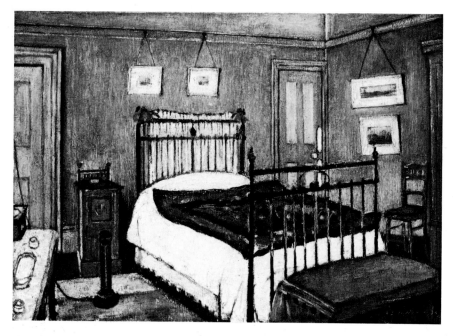

16 The Bedroom, Pendlebury 1940
oil on canvas 35.8 × 51.2cm
CITY OF SALFORD ART GALLERY
Cat. 38

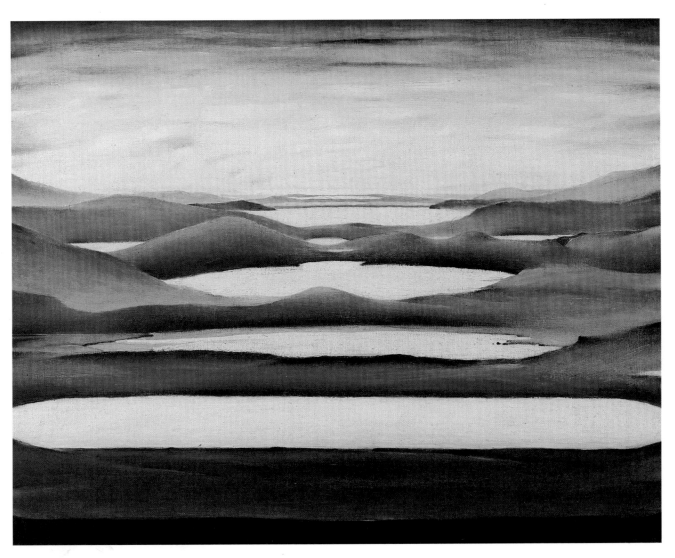

17 Lake Landscape 1950
oil on canvas 71 × 91.5cm
WHITWORTH ART GALLERY,
UNIVERSITY OF MANCHESTER
Cat. 47

'I just painted what I saw — or the way I saw it, and what I wanted to paint.' [12]

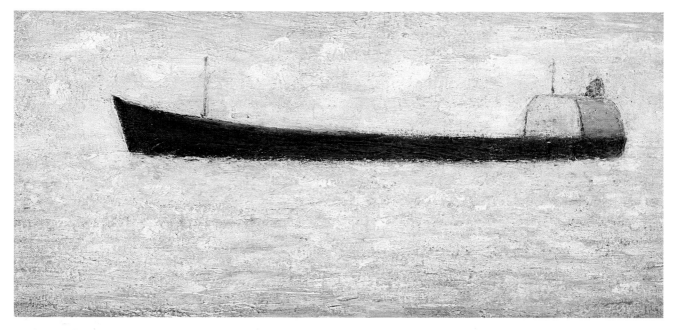

18 Waiting for the Tide, South Shields 1967
oil on canvas 15.1 × 30.5cm
CITY OF SALFORD ART GALLERY
Cat. 70

'I've a one track mind . . . I only deal with poverty. Always with gloom. You'll never see a joyous picture of mine. I never do a jolly picture. You never see the sun in my work. That's because I can't paint shadows. I kept trying for years . . . I decided to be entirely false. All my pictures are false, without shadows.' [13]

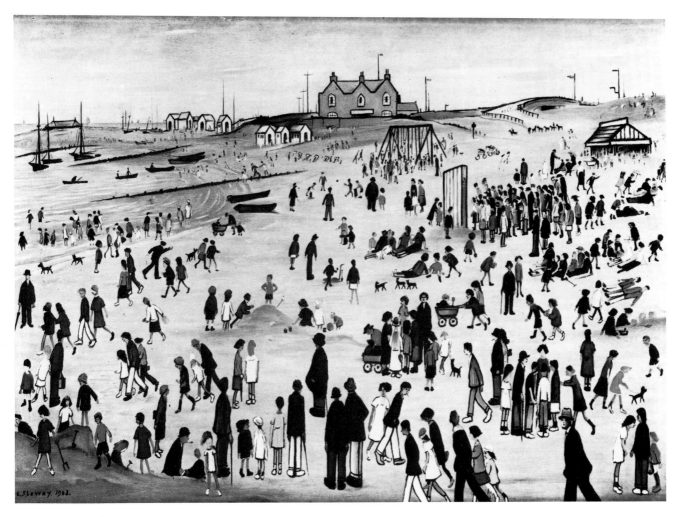

19 July, the Seaside 1943
oil on canvas 66.7 × 92.7cm
Cat. 40

'. . . the thing about painting is that there should be no sentiment. No sentiment.' [14]

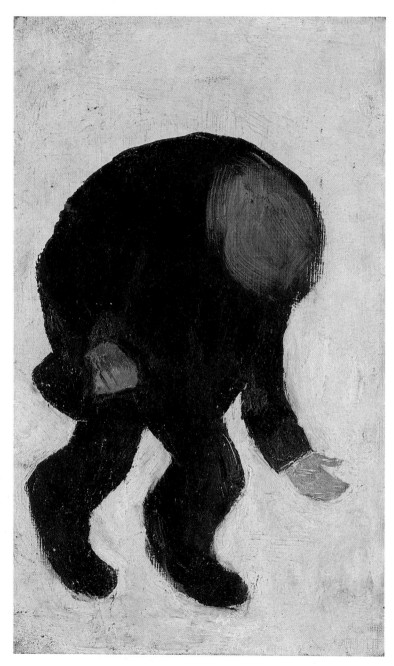

20 A Beggar 1965
oil on board 19 × 11.5cm
CITY OF SALFORD ART GALLERY
Cat. 63

'Do you know I never had a family – all I had round me was the garden fence.' [15]

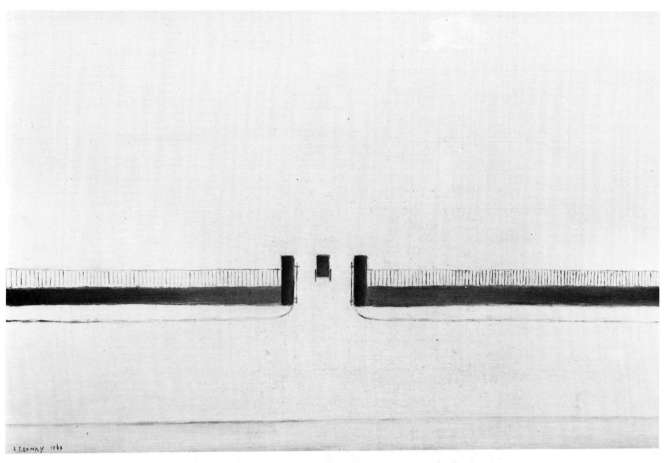

21 The Carriage 1962
oil on canvas 54 × 74cm

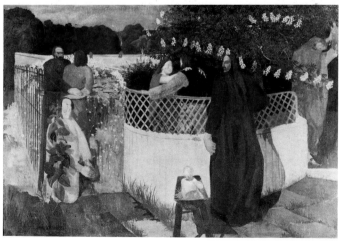

22 Stanley Spencer
The Nativity 1912
oil on panel 102.9 × 152.4cm
THE SLADE SCHOOL OF FINE
ART, UNIVERSITY COLLEGE
LONDON

LOWRY AS AN IMPRESSIONIST

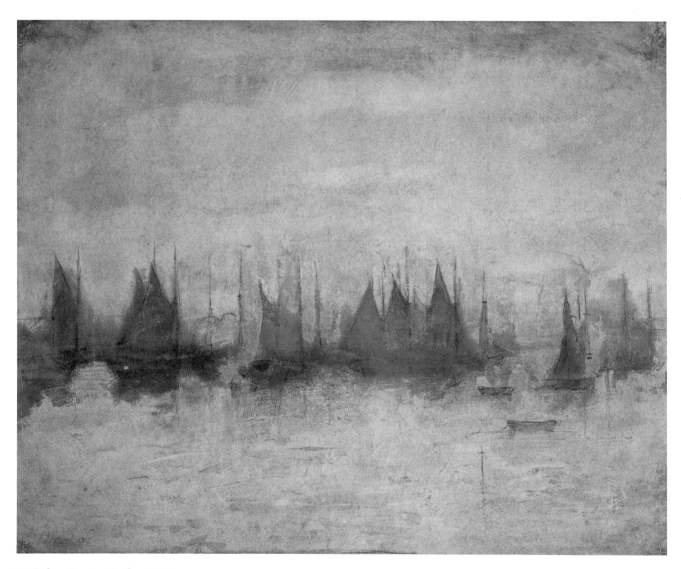

23 Fishing Boats at Lytham 1915
pastel on paper 38 × 47cm
PRIVATE COLLECTION
Cat. 8

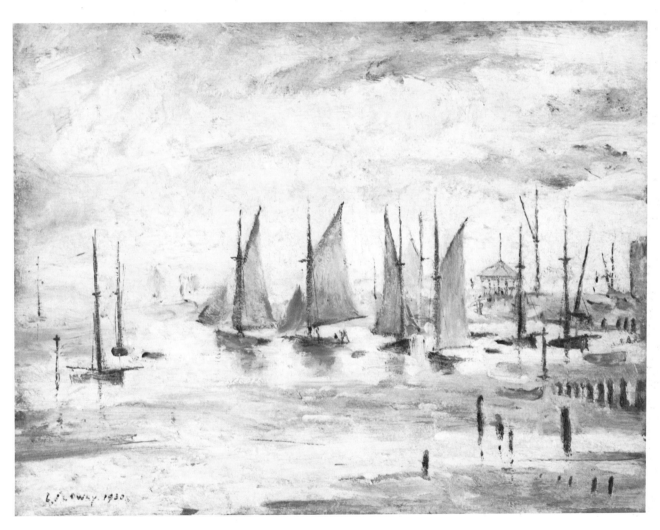

24 Sailing Boats 1930
oil on canvas 35.5 × 45.5cm
CAROL ANN DANES (ON LOAN TO CITY OF
MANCHESTER ART GALLERIES)

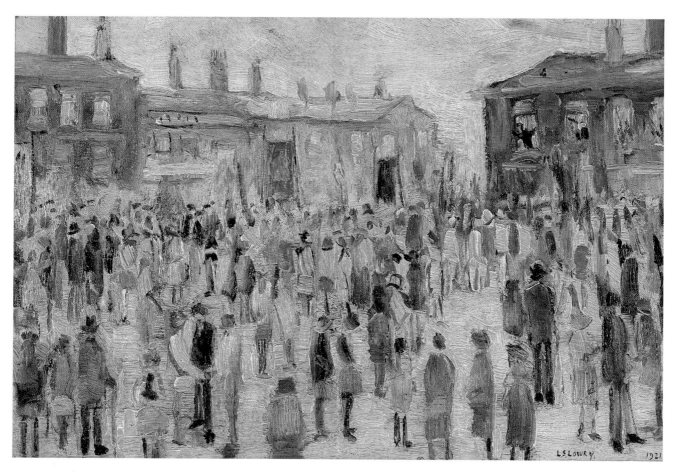

25 Whit Week Procession at Swinton 1921
oil on board 27 × 45 cm
PRIVATE COLLECTION
Cat. 18

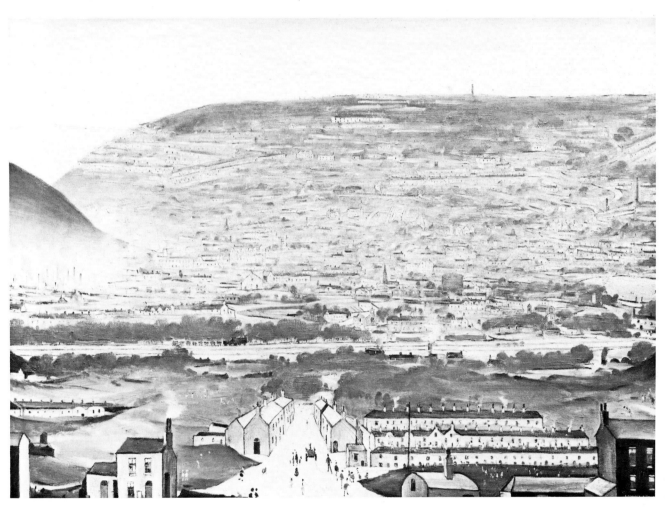

26 Ebbw Vale 1960
oil on canvas 114 × 153cm
HERBERT ART GALLERY AND MUSEUM, COVENTRY
Cat. 53

*'I was born in Old Trafford and it was in 1909 that I moved to Pendlebury, next to Salford.
I didn't like it at all, I can tell you. But I got used to it. It took a few years. Then I wasn't
only used to it, I was obsessed by it. Do you know, I painted nothing but Salford for 20
years? That's a large slice out of a man's life isn't it? It must be about the same time as
a life sentence, eh?'* [16]

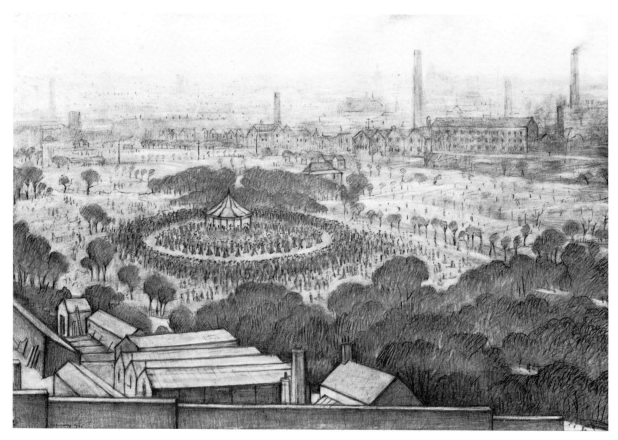

27 Bandstand, Peel Park, Salford 1925
pencil on paper 36.7 × 54.6cm
CITY OF SALFORD ART GALLERY
Cat. 22

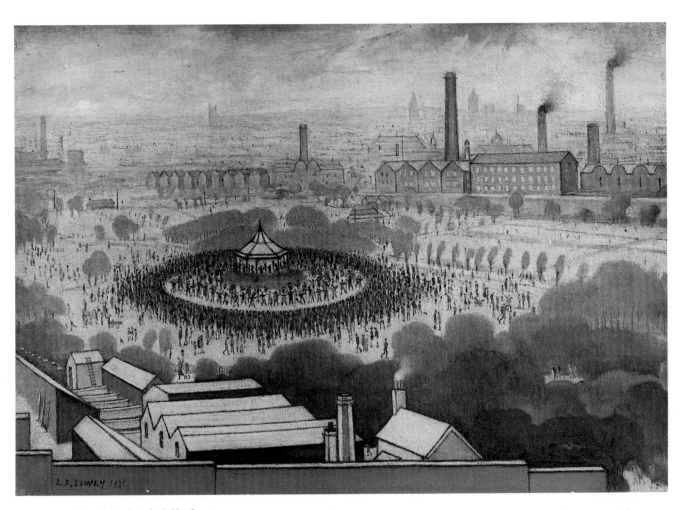

28 The Bandstand, Peel Park, Salford 1931
oil on canvas 43.2 × 62.2cm
YORK CITY ART GALLERY
Cat. 31

CROWD SCENES – RHYTHMIC ARRANGEMENTS

'I look upon human beings as automatons: to see them eating, to see them running to catch a train, is funny beyond belief . . . because they all think they can do what they want . . . and they can't, you know. They are not free. No one is.' [17]

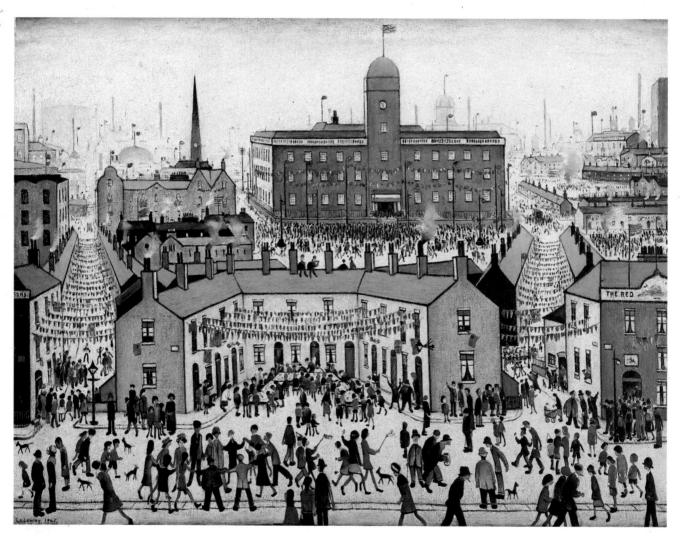

29 VE Day 1945
oil on canvas 78.7 × 101.6cm
GLASGOW ART GALLERY AND MUSEUM
Cat. 43

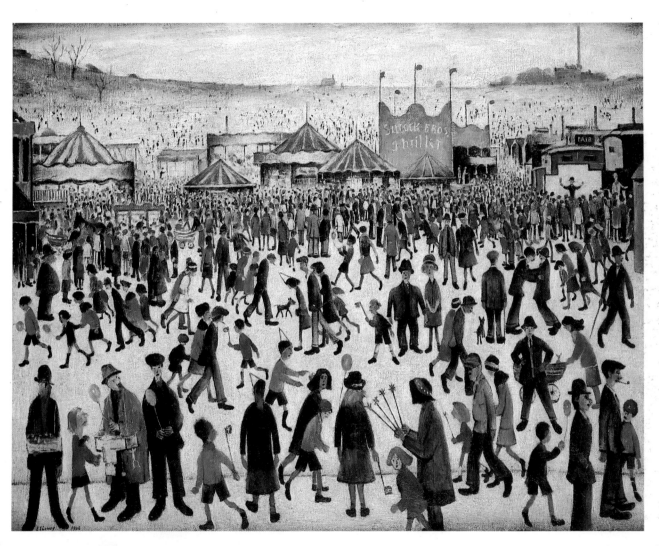

30 Good Friday, Daisy Nook 1946
oil on canvas 72.5 × 91.5cm
GOVERNMENT ART COLLECTION
Cat. 44

'I would stand for hours on one spot . . . and scores of little kids who hadn't had a wash for weeks would come and stand round me.' [18]

31 A Court, Manchester 1964
oil on canvas 39.5 × 29.5cm
COLLECTION OF L. A. AND D. C. IVES
Cat. 60

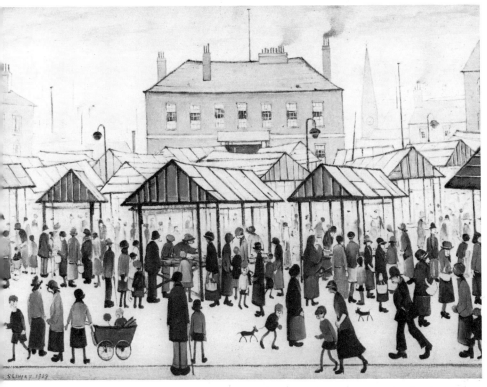

'All those people in my pictures, they are all alone you know. They have all got their private sorrows, their own absorption. But they can't contact one another. We are all of us alone — cut off. All my people are lonely. Crowds are the most lonely thing of all. Everyone is a stranger to everyone else. You have only got to look at them to see that.' [19]

32 Market Scene, Northern Town 1939
oil on canvas 45.7 × 61.1cm
CITY OF SALFORD ART GALLERY
Cat. 37

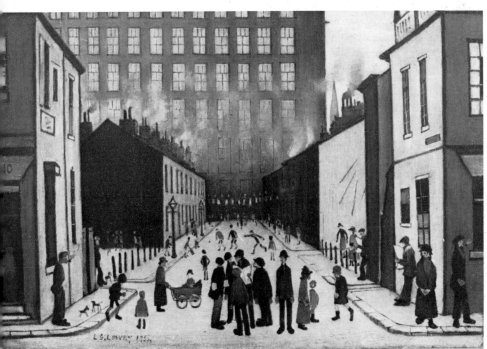

'My mood . . . is over the people in all my scenes. I could not, I did not want to, paint them as they appear. The truth is that I was not painting them. I have been called a painter of the Manchester workpeople. But my figures are not exactly that. They are ghostly figures which tenant these courts and lane-ways which seem to me so beautiful, they are symbols of my mood, they are myself.' [20]

33 Street Scene 1935
oil on canvas 43 × 53cm
THE ATKINSON ART GALLERY
METROPOLITAN BOROUGH OF SEFTON
(LIBRARIES AND ARTS SERVICES)
Cat. 33

51

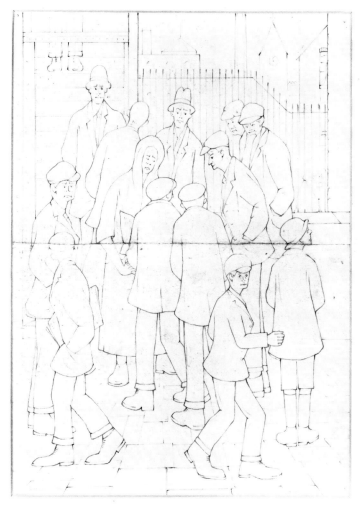

34 The Mid-day Special 1926
pencil on paper 38.4 × 27.8cm
CITY OF SALFORD ART GALLERY
Cat. 26

COMPOSITION : OFF-CENTRE AND THE GOLDEN SECTION

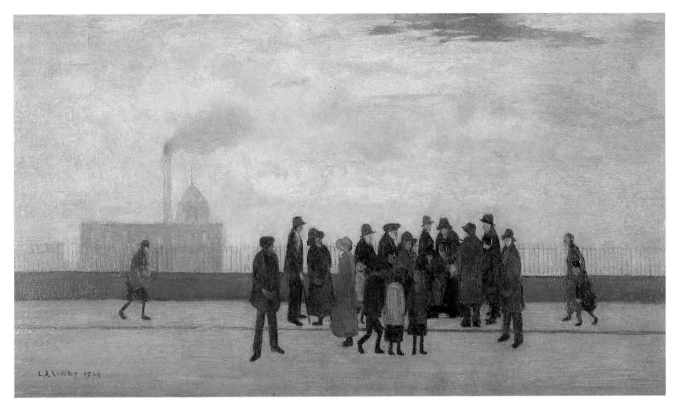

35 Sudden Illness 1920
oil on board 25 × 49cm
MARTIN D. H. BLOOM
Cat. 16

Accidents interest me – I've a very queer mind you know. What fascinates me is the people they attract, the patterns those people form, and the atmosphere of tension when something has happened . . . Where there's a quarrel there's always a crowd . . . It's a great draw. A quarrel or a body.'[21]

36 View from a Window of the Royal Technical College, Salford 1924
pencil on paper 54.4 × 37.5cm
CITY OF SALFORD ART GALLERY
Cat. 21

'Most of my land and townscape is composite . . . Made up; part real, and part imaginary . . . bits and pieces of my home locality. I don't even know I'm putting them in. They just crop up on their own, like things do in dreams.' [22]

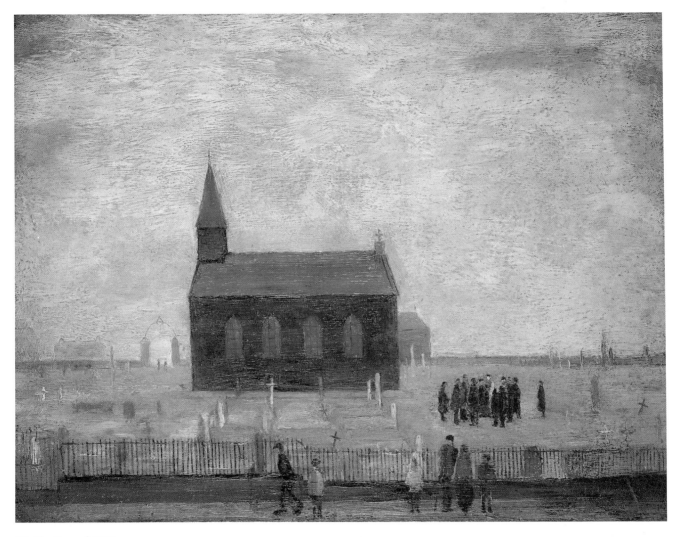

37 The Funeral 1920
oil on board 33 × 45cm
MARTIN D. H. BLOOM
Cat. 10

'I'm immensely fond of pencil. I like pencil to hang up in my house. I think there's something wonderful about a pencil drawing. I just draw, and rub it with my finger or anything else, and then fiddle with it – I think "fiddle with it" is the right term – until I get it right. Draw, then start getting tone by your finger, your pencil, india rubber of course, until it has eased up and you get it right.' [23]

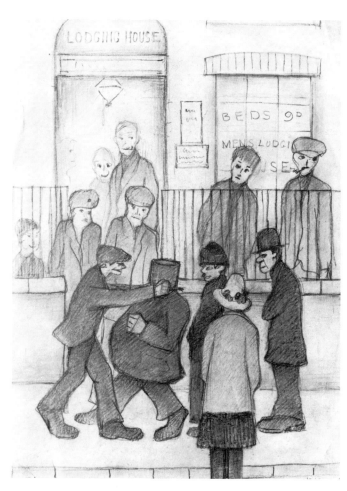

38 Outside the Lodging House 1938
pencil on white paper 38 × 28.4cm
CITY OF MANCHESTER ART GALLERIES
Cat. 35

39 The Spinner's Arms c.1920
pencil on paper 27.2 × 20.2cm
CITY OF SALFORD ART GALLERY
Cat. 15

'I like the shapes of the caps. I like the working-class bowler hats, the big boots and shawls.' [24]

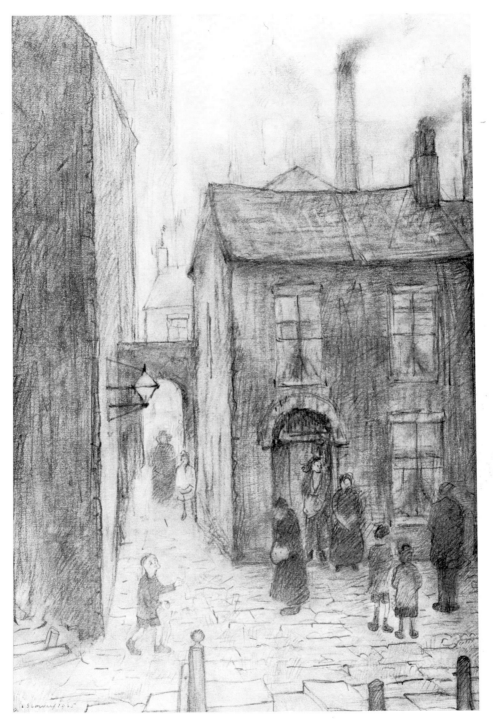

40 Lancashire Street Scene with Figures 1925
pencil on paper 35.7 × 25.5cm
WHITWORTH ART GALLERY, UNIVERSITY OF MANCHESTER
Cat. 24

COMPOSITION: CENTRAL IMAGE

41 Country Lane 1914
oil on panel 23.6 × 15.6cm
CITY OF SALFORD ART GALLERY
Cat. 6

'There must be innumerable ways of looking at the same aspects of life. A silent street, a building, for instance, can be as effective as a street full of people to me. It is the outlook or message that matters.' [25]

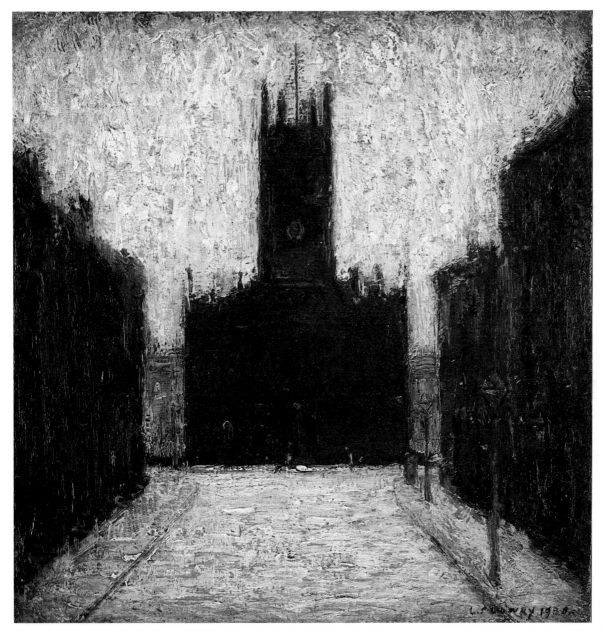

42 St John's Church, Manchester 1938
oil on canvas 30 × 29cm
Cat. 36

43 Maryport 1960
oil on canvas 47 × 59cm
MARTIN D. H. BLOOM
Cat. 55

'It's the Battle of Life — the turbulence of the sea — and life's pretty turbulent, isn't it? I am very fond of the sea, of course, I have been fond of the sea all my life: how wonderful it is, yet how terrible it is. But I often think . . . what if it suddenly changed its mind and didn't turn the tide? And came straight on? If it didn't stop and came on and on and on and on and on . . . That would be the end of it all.' [26]

44 Seascape 1952
oil on canvas 39.5 × 49.3cm
CITY OF SALFORD ART GALLERY
Cat. 48

I'm attracted to decay, I suppose; in a way to ugliness too. A derelict house gets me.'[27]

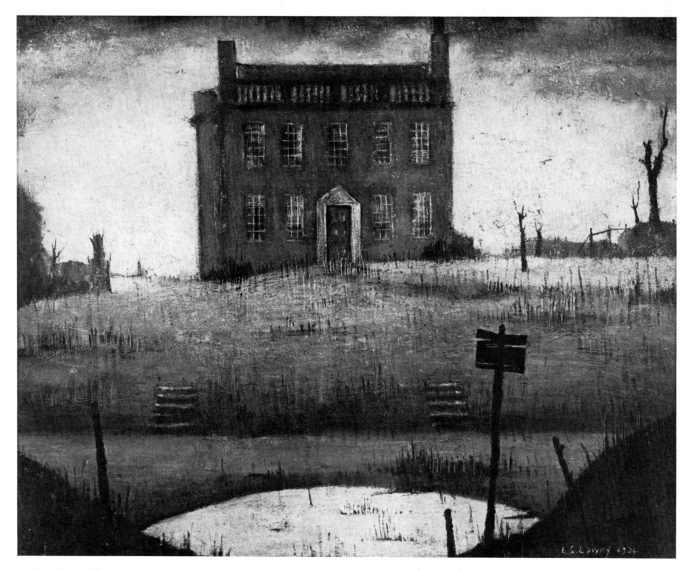

45 The Empty House 1934
oil on plywood 43.2 × 51.3cm
STOKE-ON-TRENT CITY MUSEUM AND ART GALLERY
Cat. 32

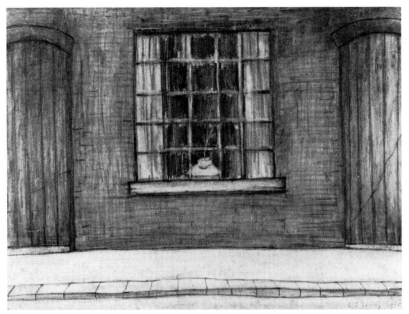

46 Flowers in a Window 1945
pencil on paper 25 × 33.7cm
MAITLAND COLLECTION
Cat. 42

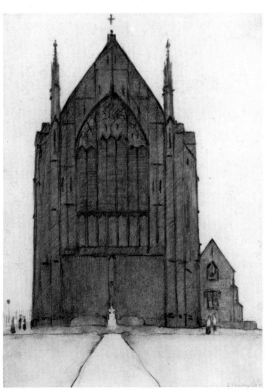

47 The Rock 1968
pencil on paper 41.7 × 29.6cm
CITY OF SALFORD ART GALLERY
Cat. 71

48 St Augustine's Church, Pendlebury 1930
pencil on paper 35.1 × 26cm
CITY OF SALFORD ART GALLERY
Cat. 30

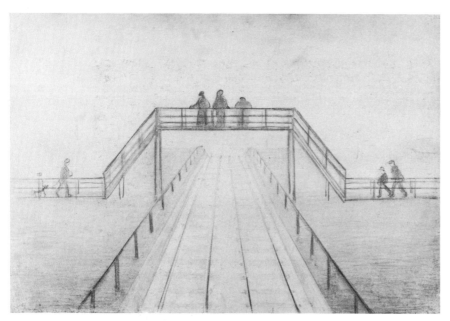

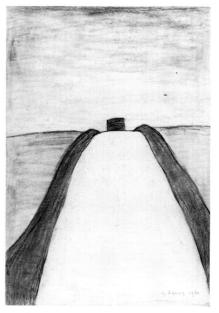

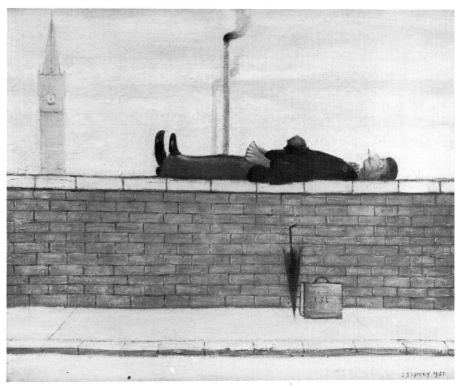

**49 Bridge with Figures over
Colliery Railway** c.1925
pencil on paper 37 × 55cm
CITY OF SALFORD ART GALLERY
Cat. 23

50 Over the Hill 1961
pencil on paper 34.5 × 25.1cm
CITY OF SALFORD ART GALLERY
Cat. 56

*'It was a hot, summer day,
and I was sitting in a bus when
we suddenly passed the man
on the wall, just as you see him
in my painting.'* [28]

51 Man Lying on a Wall 1957
oil on canvas 40.7 × 50.9cm
CITY OF SALFORD ART GALLERY
Cat. 50

COMPOSITION: CENTRAL IMAGE – PEOPLE

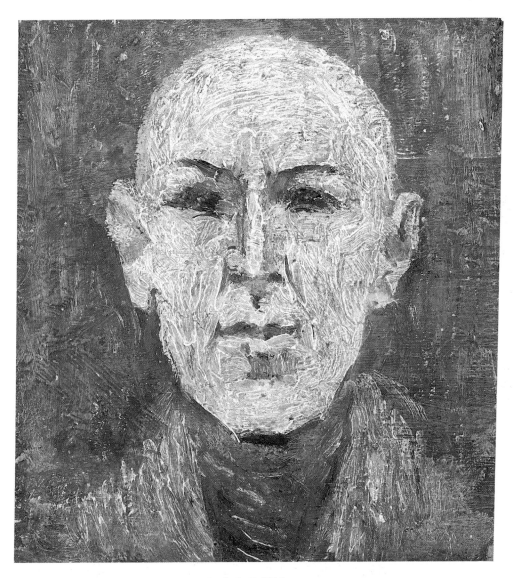

52 Head of a Bald Man c.1913–14
oil on panel 28.7 × 18.2cm
CITY OF SALFORD ART GALLERY
Cat. 5

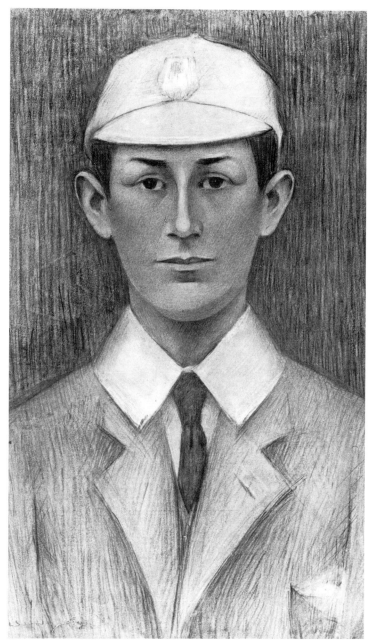

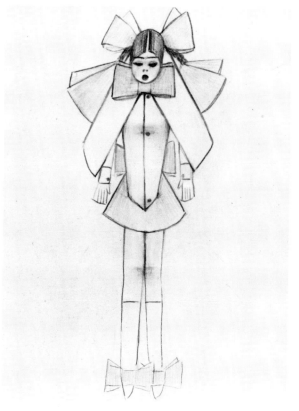

54 Girl with Bows c.1973
pencil on paper 28.2 × 22.3cm
CITY OF SALFORD ART GALLERY
Cat. 79

53 Boy in a Schoolcap 1912
pencil and white chalk on paper 42.5 × 24.5cm
CITY OF SALFORD ART GALLERY
Cat. 4

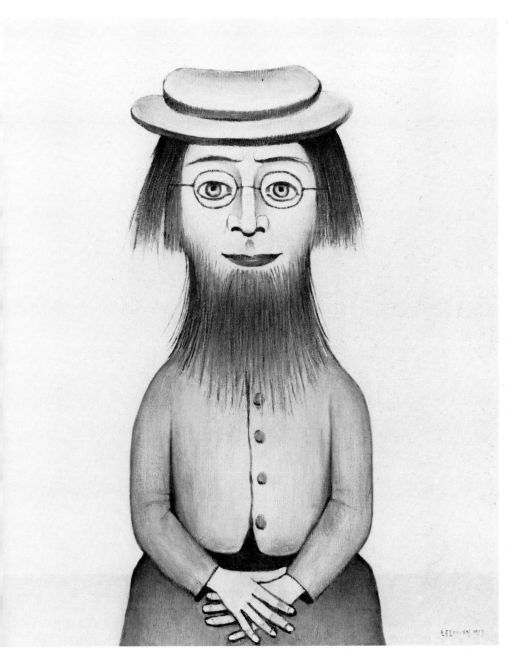

'She had a very nice face, and quite a big beard. Well sir, I just couldn't let such an opportunity pass, so I began almost at once to make a little drawing of her on a piece of paper. She was sitting right opposite me. After a while she asked, rather nervously what I was doing? I blushed like a Dublin Bay prawn and showed her my sketch – the one from which I later made my painting of her. At first she was greatly troubled but we talked, and by the time the train had reached Paddington we were the best of friends. We even shook hands on the platform.'[29]

'An intelligent and sweet woman – completely alone and isolated behind her deformity. No way of reaching her.'[30]

55 Woman with a Beard 1957
oil on canvas 59 × 49cm
MARTIN D. H. BLOOM
Cat. 52

PSYCHOLOGICAL RELATIONSHIPS

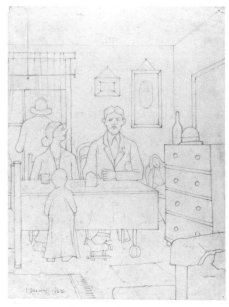

56 Interior Discord 1922
pencil on paper 27.1 × 20.9cm
SUNDERLAND MUSEUM AND ART GALLERY
(TYNE AND WEAR MUSEUMS SERVICE)
Cat. 19

57 Three Figures (Mother and Sons) 1967
oil on canvas 50 × 40cm
MARTIN D. H. BLOOM
Cat. 69

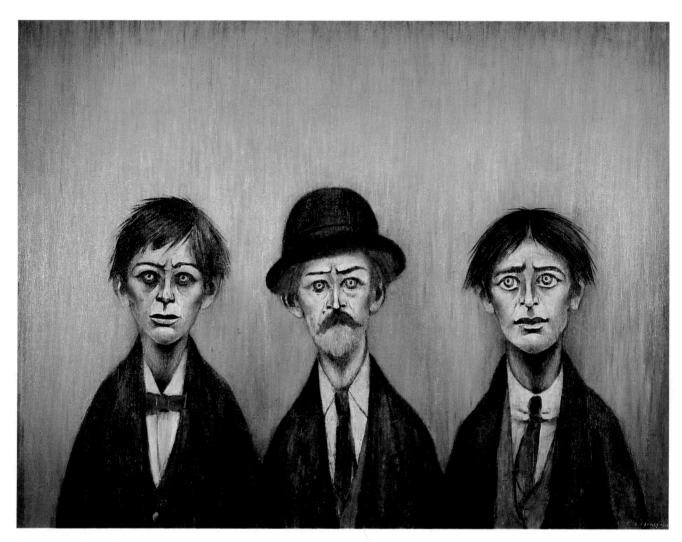

58 Father and Sons 1950
oil on canvas 75 × 100cm
MARTIN D. H. BLOOM
Cat. 46

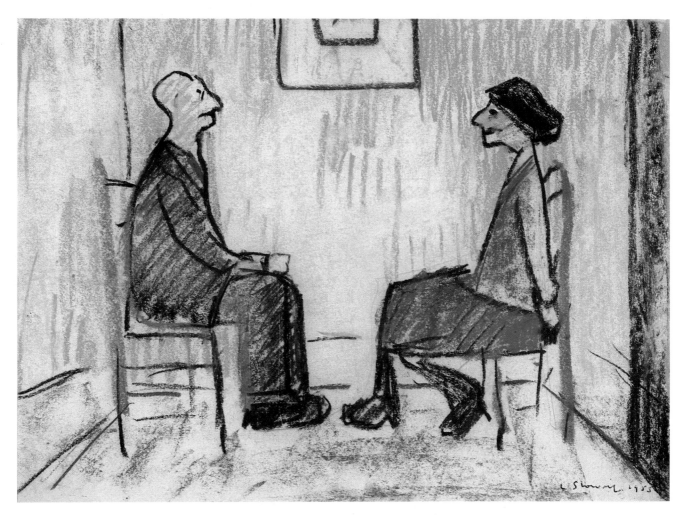

59 Courting 1955
coloured pencil and crayon on paper 25 × 35cm
PRIVATE COLLECTION
Cat. 49

LOWRY AS AN EXPRESSIONIST

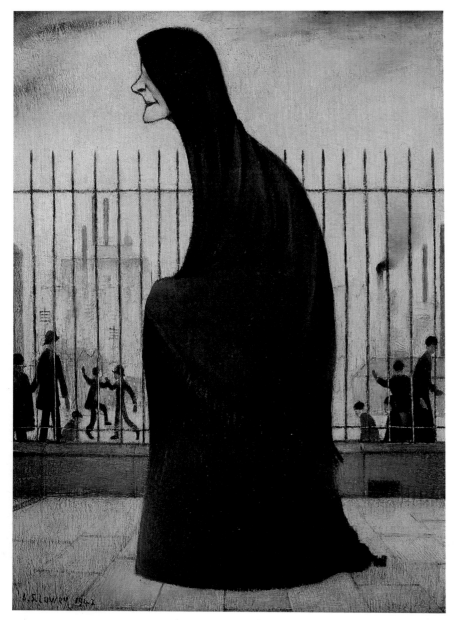

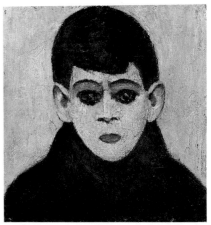

'There's a grotesque streak in me and I can't help it. My characters? They are all people you might see in a park . . . They are real people, sad people . . . I'm attracted to sadness, and there are some very sad things.' [31]

61 Head of a Boy c.1960
oil on board 21.5 × 21cm
CITY OF SALFORD ART GALLERY
Cat. 54

60 An Old Lady 1942
oil on canvas 50 × 42.5cm
MAITLAND COLLECTION
Cat. 39

'I'm much more interested in deformed people because . . . oh, because they look so comic.' [32]

'I have operated on one of the gentlemen in the far distance and given him a wooden leg . . .
I still laugh heartily at the hook on the arm of the gentleman.' [33]

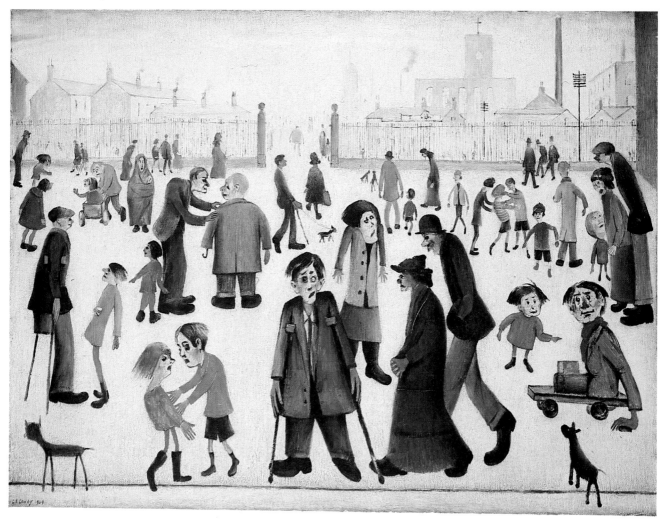

62 The Cripples 1949
oil on canvas 76.3 × 101.8cm
CITY OF SALFORD ART GALLERY
Cat. 45

'I think that this is my best period. I think I am saying more, going deeper into life than I did.' [34]

63 Office Head c.1920
pen and ink on paper 20 × 20.8cm
CITY OF SALFORD ART GALLERY
Cat. 11

64 Office Head c.1920
pen and ink on paper 20.5 × 20.7cm
CITY OF SALFORD ART GALLERY
Cat. 12

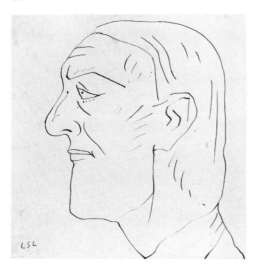

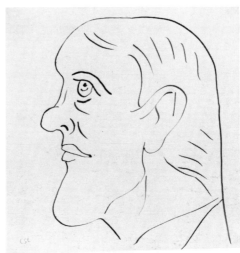

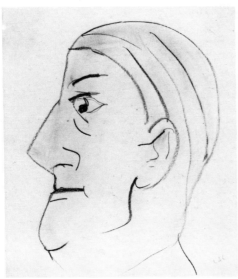

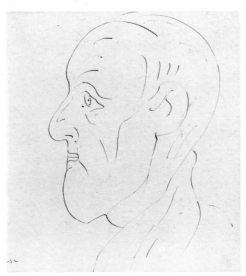

65 Office Head c.1920
pen and ink on paper 21.3 × 20.7cm
CITY OF SALFORD ART GALLERY
Cat. 13

66 Office Head c.1920
pencil on paper 21 × 20cm
CITY OF SALFORD ART GALLERY
Cat. 14

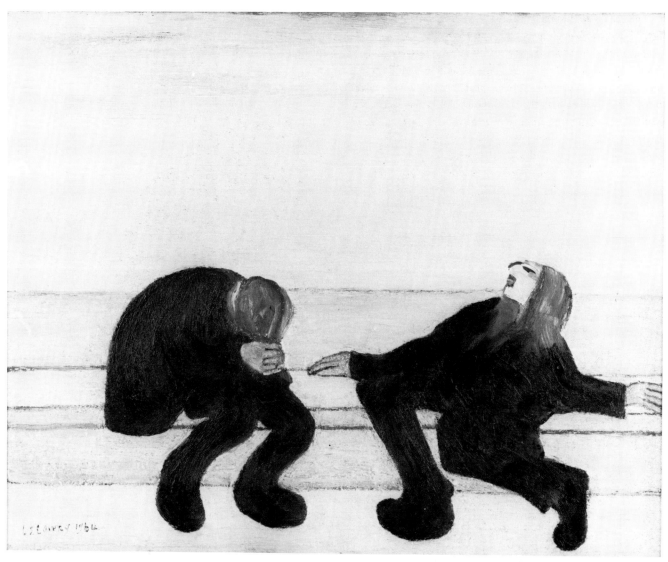

67 Two Men on a Park Bench 1964
oil on canvas 39 × 49cm
MARTIN D. H. BLOOM
Cat. 62

'I wanted to show people that there were these people about. And I was sorry for them, and at the same time realising that there was really no need to be sorry for them because they were quite in a world of their own.' [35]

'. . . all the time I'm thinking about what happened to them and how they got in that state. Some people shoot themselves, some people drink themselves to death and other people go like that, taking the line of least resistance. The sad thing is, we can't do anything about it. And this could happen to any of us if we were faced with a crisis. I feel certain all of them had a crisis of some sort which they weren't quite proof against. In many cases it could be drink alone but I think in many cases it's more than that — shock very often, I should say. Well, I am very sorry for them. I wonder about them. And when you talk to them, very often, in most cases, in fact, they're very interesting people.' [36]

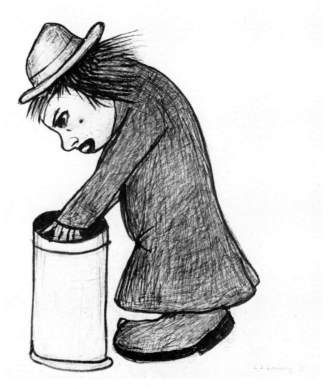

69 The Tramp, St Peter's Square 1971
pencil on paper 41 × 29.5cm
COLLECTION OF L. A. AND D. C. IVES
Cat. 76

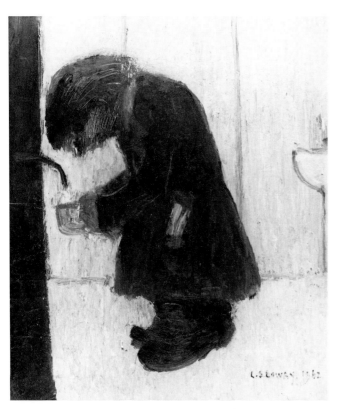

68 Man Drinking Water 1962
oil on board 37 × 31cm
MARTIN D. H. BLOOM
Cat. 58

'I feel more strongly about these people than I ever did about the industrial scene . . . There but for the grace of God go I.' [37]

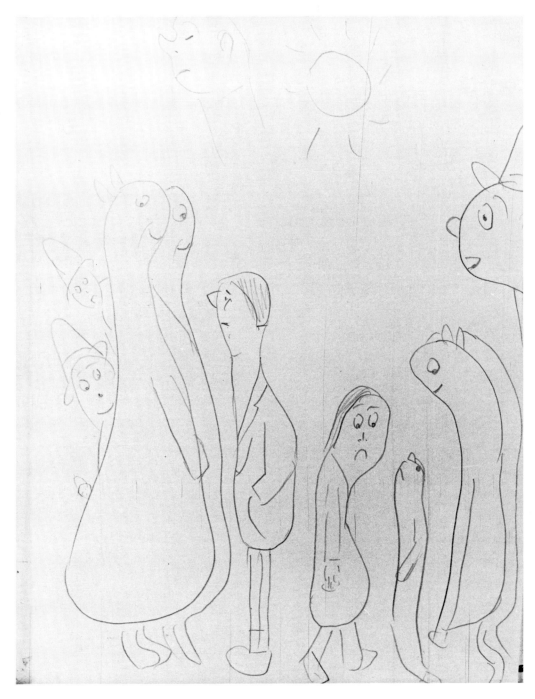

70 Meeting Friends c.1970
pencil on paper 30.6 × 22.7cm
CITY OF SALFORD ART GALLERY
Cat. 74

71 In the Sea c.1970
pencil on paper 29.6 × 41.9cm
CITY OF SALFORD ART GALLERY
Cat. 73

72 A Game of Marbles 1970
pencil on paper 25.2 × 35.3cm
CITY OF SALFORD ART GALLERY
Cat. 72

'People say to me: "You can't see characters as weird as that", but there's not one of them I haven't seen. I saw a woman in Manchester with two club feet and she shouted at me: "What the bloody hell are you looking at" and then she started laughing, he he he he. Poor old soul.' [38]

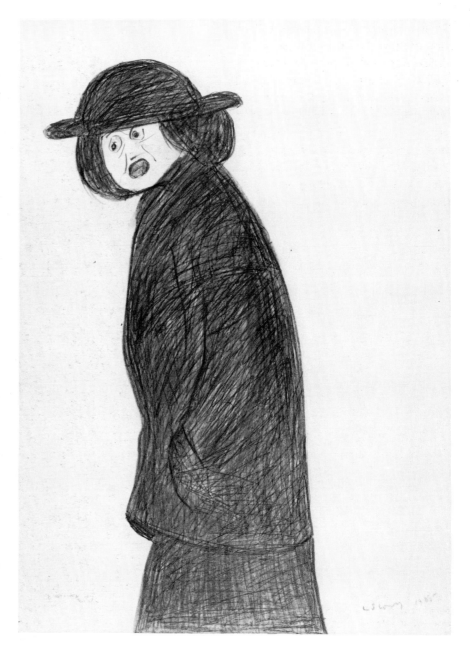

73 Woman in Black 1965
pencil on paper 34.7 × 25.4cm
CITY OF SALFORD ART GALLERY
Cat. 65

*'Who are they Sir? They are my friends
and neighbours. Look along Stalybridge
Road and you will see every one of them
– all done from life . . . all done from life.
That's a good title – FRIENDS AND
NEIGHBOURS – but it might offend so
let's call it FAMILY GROUP – but they
are still there, just take a look around.
What did I tell you Sir, what did I tell
you? They are all outside, every one of
them – even the dog!*[39]

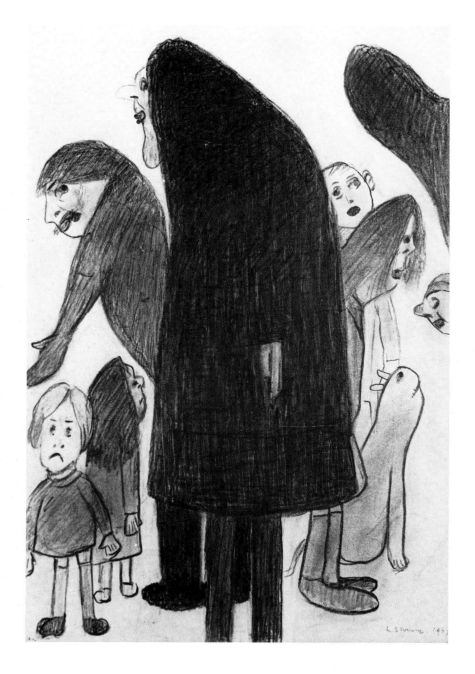

74 Family Group 1967
pencil on paper 41.7 × 29.7cm
COLLECTION OF L. A. AND D. C. IVES
Cat. 67

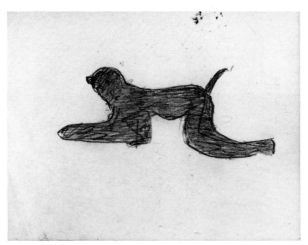

75 Pantomime Cat c.1965
pencil on paper 13.7 × 17.8cm
CITY OF SALFORD ART GALLERY
Cat. 64

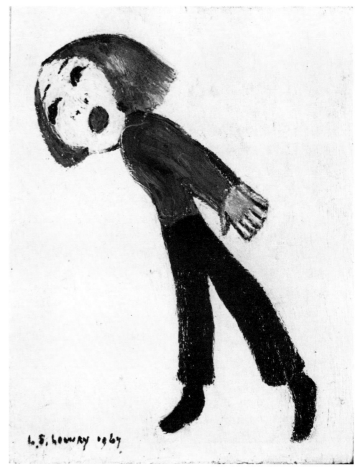

76 Girl with Red Scarf and Black Trousers 1967
oil on canvas 26.5 × 19.5cm
COLLECTION OF L. A. AND D. C. IVES
Cat. 68

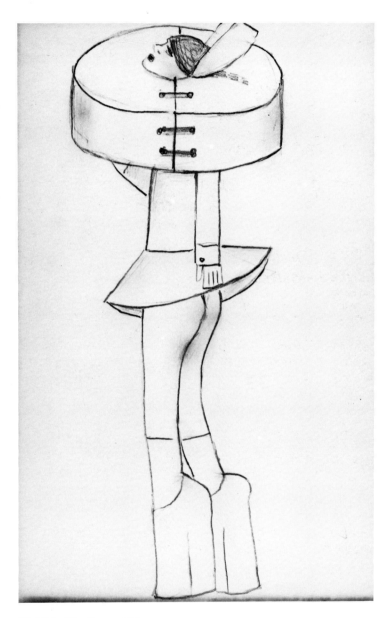

77 Girl with a Bow c.1973
pencil on paper 33 × 21.5cm
CITY OF SALFORD ART GALLERY
Cat. 77

LOWRY
THE JESTER

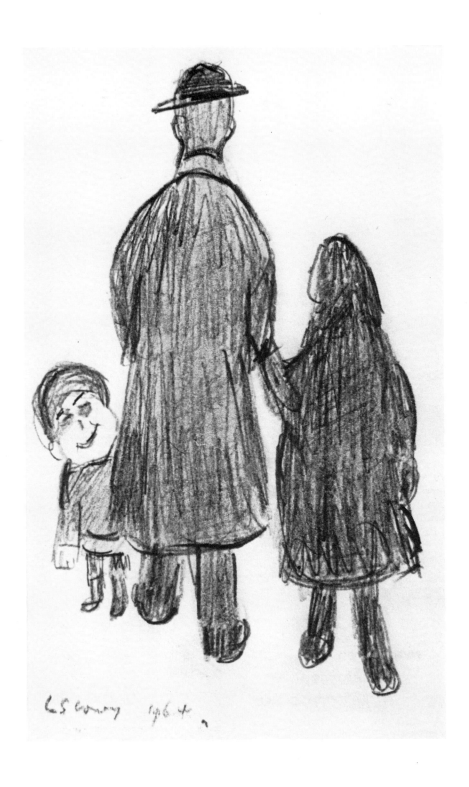

*'I used to see them in
Stalybridge. Isn't she a little
woman? That's what
happens when you get
married, Sir, but you have
got one of my best!'*[40]

78 The Family 1964
pencil on paper 20 × 12.7cm
COLLECTION OF L. A. AND D. C. IVES
Cat. 61

82

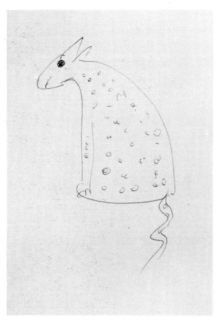

80 Spotted Dog 1963
black ballpoint pen on paper 17.8 × 12.8cm
CITY OF SALFORD ART GALLERY
Cat. 59

79 Minimal Drawing of a Girl 1966
pencil on paper 21.7 × 15.5cm
CITY OF SALFORD ART GALLERY
Cat. 66

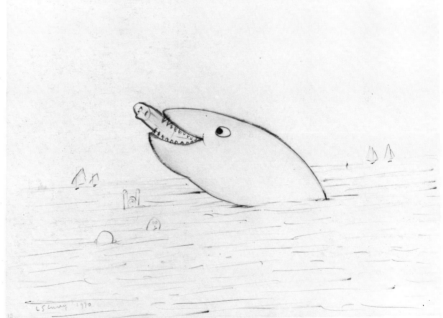

81 The Shark 1970
pencil and black ballpoint pen on paper 25.4 × 35.6cm
CITY OF SALFORD ART GALLERY
Cat. 75

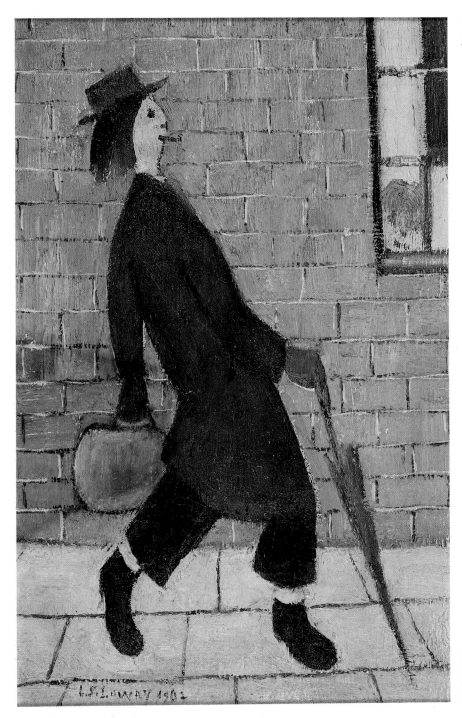

*'I am not an artist,
I'm just a man who paints.'* [41]

82 Father Going Home 1962
oil on canvas 37 × 25cm
MARTIN D. H. BLOOM
Cat. 57

CHRONOLOGY

1887 Lawrence Stephen Lowry, born 1 November in Old Trafford, Manchester. Only child of Robert Lowry, a rent collector and clerk in an Estate Agent's office and Elizabeth (née Hobson), an 'accomplished pianist' who collected clocks and china.

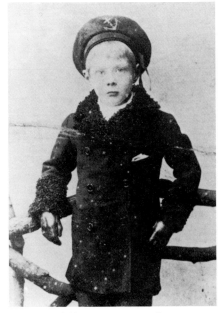

Lowry as a child, c.1894, Private Collection

1895 Started at Victoria Park School, Manchester.

1898 The family moved to 14 Pine Grove, on the fringes of Victoria Park, a private residential estate.

1903 Having been rejected as a full-time student at Manchester Municipal College of Art became clerk with Messrs Thomas Aldred and Son, Chartered Accountants, Mosley Street, Manchester.

Began attending the private classes of Reginald Barber in his studio in Brown Street.

1905 Accepted as an evening pupil in preparatory antique and freehand drawing at Manchester Municipal College of Art. Studied there until 1915, progressing to the life class, which was taught by Adolphe Valette. Lowry remained grateful to Valette: 'I owe so much to him, for it was he who first showed me good drawings, by the great masters. He was a real teacher . . . a dedicated teacher'[1] and 'he gave me the feeling that life drawing was a very wonderful thing, as I saw it done by himself and his friends. I had not seen drawings like these before – for artistry. They were French life-class drawings, and he painted and drew in the same way. I was fascinated by it, and whilst I never drew in that way – I couldn't have done, it wasn't my way of drawing – I greatly admired him and they helped me very much. They were great stimulants.'[2]

1907 Began private classes with the American portrait painter William Fitz (continued until shortly before Fitz's death in 1915). Lowry later said, 'Billy Fitz was very good in making research on the forms of anything. You had to search for the forms, and then work on that. They looked as if they were cut out of paper. It did me a lot of good. He was a competent painter, but I don't think he was very distinguished. That doesn't matter. A teacher doesn't need to be distinguished.'[3]

Became clerk in office of General Accident Fire and Life Assurance Corporation – made redundant in 1910.

1909 Family moved from residential area of Manchester to 117 Station Road, Pendlebury, Swinton, an industrial suburb. 'My subjects were all around me . . . in those days there were mills and collieries all around Pendlebury. The people who worked there were passing, morning and night. All my material was on the doorstep.'[4] '. . . we went to Pendlebury, midway between Manchester and Bolton, which in those days was a particularly industrial area. The whole stretch from Bolton to Manchester was entirely industrial. At first I disliked it. After a year I got used to it. Within a few years I began to be interested and at length I became obsessed by it.'[5]

1910 Became rent collector and clerk for the Pall Mall Property Company, Manchester, the firm he worked for until his retirement.

1912 Saw Stanley Houghton's new realist play *Hindle Wakes*, with its industrial subject matter, in its production by Miss Horniman's Repertory Company at the Gaiety Theatre, Manchester. The stage settings for the first act are described: 'through the kitchen window can be seen the darkening sky. Against the sky an outline of rooftops and mill chimneys. The only light is the dim twilight from the open window.' Lowry emphasised the influence of this production on the shaping of his vision.

1915 Began life classes at Salford School of Art – taught by Bernard D. Taylor, who as critic for the *Manchester Guardian* reviewed his 1921 exhibition. Taylor is also said to have been responsible for Lowry's conversion to the use of white grounds: 'At first I was painting very black, very dark. Then I was given a shock. I had a picture of an industrial scene that was very darkly painted. I took it to Taylor of the *Guardian* who was a very good friend to me in those days. He said, "That's no good at all, you know, no good at all." "Why?" I said. I was very annoyed with him. "Well," he said, "look at it." And he held it up against the wall, which was darkly coloured as they were in those days, and my picture was black. He said, "You'll have to paint your pictures so that they stand out against the wall even if they are industrial scenes." "How do I do that?" I asked. He said,

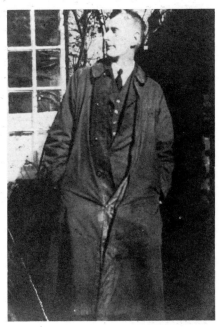

Lowry as a young man, c.1917, Private Collection

"That's your affair, not mine." I was very angry with him, very cross indeed. But I went away and I painted a couple of figures on a pure white background and I took them to him. "That's what I meant," he said, "that's the thing to do." And he was right.'[6]

1918 Accepted for life class of Manchester Academy of Fine Arts.

1919 Three works included in Annual Exhibition of Manchester Academy of Fine Arts at Manchester City Art Gallery.

1921 Exhibited, with Roland Thomasson, an architect, and Tom H. Brown, in Thomasson's offices in Mosley Street. Not one Lowry sold. Among works exhibited were *The Lodging House* (plate no. 6) and *Sudden Illness* (plate no. 35). Reviewing the show in the *Manchester Guardian* Bernard Taylor wrote: 'His subjects are Manchester and Lancashire street scenes, interpreted with technical means as yet imperfect, but with real imagination. His portrait of Lancashire is more grimly like than a caricature, because it is done with the intimacy of affection. He emphasises violently everything that industrialism has done to make the aspect of Lancashire more forbidding than of most other places . . . he has kept his vision as fresh as if he had come suddenly into the most forbidding part of Hulme or Ancoats under the gloomiest skies after a holiday in France or Italy. His Lancashire is grey, with vast rectangular mills towering over diminutive houses. If there is an open space it is of trodden earth, as grey as the rest of the landscape. The crowds which have this landscape for their background are entirely in keeping with their setting; the incidents in the drama of which they are the characters are also appropriate . . .

'We hear a great deal nowadays about recovering the simplicity of vision of the primitives in art. These pictures are authentically primitive, the real thing, not an artificially cultivated likeness to it. The problems of representation are solved not by reference to established conventions but by sheer determination to express what the artist has felt, whether the result is according to rule or not. The artist's technique is not yet equal to his ideas. If he can learn to express himself with ease and style and at the same time preserve his singleness of outlook he may make a real contribution to art.'

Lowry remembered for the rest of his life this sympathetic review, which came at a time when his achievement was unrecognised and misunderstood.

1920s Daisy Jewell (wife of W. H. Berry, Director of Oldham Art Gallery), head of the framing department of the fine art agents James Bourlet and Sons Ltd, London, championed him, and encouraged him to exhibit widely – in Paris at the Salon and the Salon d'Automne, with the New English Art Club (1927–36 and then intermittently to 1957), in Dublin at the Salon, in Japan and with the Society of Modern Painters, Manchester. Work did not sell. In 1928 a reviewer of the Paris Salon wrote 'Lorence [sic] Lowry expose deux toiles qui soit d'un observateur amusé et d'un peintre délicat'.

1927 A painting, *Coming out of School* bought for the Duveen Fund – a scheme run by the Tate Gallery and set up as a way of purchasing works by contemporary British artists for presentation to museums and as a resource for touring exhibitions. A journalist for the *Eccles Journal* took it that the work had been bought by the Tate for its national collection of British art: 'Mr Lowry is, one believes, the first local artist to have been bought by the Tate Gallery.' (The picture was not hung there until 1949.) The article apparently caused some embarrassment to Lowry. The rest of the piece gives a sense of the way Lowry presented himself at this time: 'He has not, until recently, exhibited very widely, because, as he told a *Journal* representative this week, he was still working out the problem of how to present on canvas the scenes he saw in the industrial environment of Lancashire. His work belongs to no definite "school" of painting; it is very individual in treatment and method. He has tried, he said, to represent scenes not as a photographic record but as their meaning occurred to him. All his recently exhibited work is industrial in character. When Mr Lowry first came to Pendlebury, he was, he declares, depressed by the squalor of some of the things he saw. Later, however, he began to see something behind the apparent drabness of the poverty, and, leaving behind portrait work, of which he had done a large amount, he began to apply himself to the problem of how to treat industrial scenes as he observed them. He does a considerable amount of sketching but not as

a basis for his painting. He paints entirely from memory and his sketching is done solely for practice in drawing. Mr Lowry studied at the Manchester and Salford Schools of Art for many years. He devotes a very considerable part of his time to Art and indeed, has always done so. The public will have a greater opportunity of seeing his work in the near future as he intends to exhibit more widely than he has done in the past.'

1930 One-man exhibition of drawings at The Round House, Manchester University Settlement, in Every Street. All work sold – first work acquired by Manchester City Art Gallery (Rutherstone Collection).

Invited by author to illustrate Harold Timperley's *A Cotswold Book* (published 1931, Jonathan Cape). As information for the publishers, described himself: 'a regular exhibitor at the Paris Salon, the Salon d'Automne, the New English Art Club under the Duveen Scheme, an exhibitor by invitation at many Corporation Galleries, at the Royal Scottish Academy and the Royal Hibernian Academy in Dublin, had just had an invitation to submit a picture for the Canadian National Exhibition in Toronto, had drawings and paintings illustrated in various periodicals, a picture bought by the Duveen Fund and one oil painting bought by Rye Art Gallery.'[7]

1931 Lowry included in Edouard-Joseph's *Dictionnaire Biographique des Artistes Contemporains 1910–1930* (*Art and Edition*, 3 vols) described as 'Eleve de l'Ecole des Beaux Arts de Manchester et puis de Salford' – a specialist in oil paintings and drawings of industrial street scenes. *Self-Portrait* (plate no. 2) illustrated.

1932 Father died. Lowry was seldom warm in his recollection of his father, but later recalled that this remote figure had taken enough interest in his work to recommend that he paint St Simon's Church, Salford (plate no. 7) just before it was demolished; he reported his father as having said: 'You'll really have to go and see that St Simon's Church. It's your cup of tea and it's going to come down very soon.'[8] He also said that his father had been interested in the experiment he carried out in 1924 on the white grounds: 'I got a little piece of wood and painted it flake-white six times over. Then I let it dry and sealed it up; and left it like that for six or

seven years. At the end of that time I did the same thing again on another piece of board, opened up the first piece I'd painted and compared the two . . . The recent one was of course dead white; but the first had turned a beautifully creamy grey-white. And then I knew what I wanted. So, you see, the pictures I've painted today will not be seen at their best until I'm dead, will they?'[9]

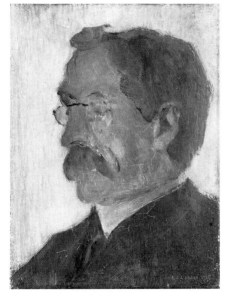

Portrait of the artist's father, 1910

On his father's death discovered that there had been serious financial difficulties, and that there were debts to pay.

First exhibited at the Royal Academy.

Exhibited with Manchester Academy (and then almost every year to 1972).

1933 Exhibited with the Royal Society of British Artists.

Outraged by article in the *Manchester Evening News* (7 June) which revealed his full-time job: 'Mr Lowry is assistant secretary to a well-known Manchester firm of property and estate agents, and he does much of his work in the evenings . . . Art to Mr Lowry is the antidote to a day of strain at a city desk.' From this time he studiously kept the secret of his job (which was only revealed after his death), and fought against the damaging charge of being an amateur, 'a Sunday Painter'.

1934 Elected Member of Manchester Academy of Arts and member of the Royal Society of British Artists.

Throughout the '30s exhibited extensively in mixed exhibitions.

His mother had been an invalid for some years, now bedridden and increasingly demanding.

1936 Included in mixed exhibition at the Arlington Gallery, London.

First picture (*A Street Scene – St Simon's Church*, 1928, plate no. 7) acquired by Salford Art Gallery.

1938 A. J. McNeill Reid, Director of Alex Reid and Lefevre Gallery, London, saw Lowry's paintings while visiting James Bourlet and Sons Ltd.

1939 *January:* First one-man exhibition, Alex Reid and Lefevre Gallery, London. The start of a long association with the gallery. Sixteen works sold and picture acquired by the Tate. Eric Newton reviewed the show for *The Sunday Times:* 'Mr Lowry has formulated his own creed and consequently he will fit into no pigeonhole. His vision is personal to himself and owes nothing to any other artist. Like Cézanne he has gone straight to life . . . and his only concern as an artist is to translate his attitude to it in paint. He belongs to no school, but he may ultimately be the founder of one.' The *London Mercury* critic wrote: 'His paintings must be the result of much thought, constant observation, and complete mastery of his formula or convention . . . [the paintings are] sharp cut mental reconstructions of reality, composed of well-observed and thoroughly digested effects of incident and atmosphere and for that reason they are even more impressive than realistic renderings.' Other comments included: 'His technique is almost childish' (*The Star*); 'His art is not great art; but it is so genuine that one accepts it gladly in the spirit in which it is offered' (*Apollo*) and 'crude, awkward and primitive' (*Time and Tide*).[10]

October: Death of his mother. There has been much discussion of Elizabeth Lowry's domineering qualities. She appears to have belittled her son as a child and consistently to have disliked his art; but the emotional link was so strong that Lowry, exhausted by nursing her, was devastated by her death. When he was 80 he

said, 'I've not cared much about anything since she died. I've nothing left and I just don't care. Painting is a wonderful way of getting rid of the days.'[11] Of his mother he declared: 'She didn't understand my art but she understood me and that was enough.'[12]

1941 One-man exhibition at Salford Art Gallery.

Portrait of the artist's mother, 1910

1943 One-man exhibition at the Bluecoat Chambers, Liverpool.

Exhibited at 117A Oxford Road, Manchester, with Manchester Ballet Club (from which Manchester Art Club formed in 1946).

Exhibition (with Josef Herman) at Alex Reid and Lefevre. Maurice Collis reviewed the show for *Time and Tide:* 'The construction of his street scenes is instinctive and subtle; their multitudinous figures, thrown on apparently haphazard, form a pattern actually quite balanced, a balance not only of design but of colour . . . the synthesis is new each time.'

1944 Exhibition in Edinburgh arranged by McNeill Reid.

1945 Made Honorary M.A., University of Manchester.

Second one-man show, Lefevre Gallery (and then 1947, 1948, 1951, 1953, 1956, 1958, 1961,

1963, 1964, 1967, 1968, 1971, 1974, 1976). Reviews of this show included those in the *Manchester Guardian*: 'Here is a completely independent artist with subject matter of his own and a style which has nothing to do with current fashion . . . strange as is his vision of industrial Lancashire, it is authentic.' And by Michael Ayrton in the *Spectator*: 'I resent the Lowry automaton so fiercely that I must concede part of his actuality by the very degree of my revulsion, but I am inclined to think that some part of Lowry's convention rises out of his inability to draw the human figure.'

1946 With other members of Manchester Art Club formed a sub-group, The Manchester Group, which showed at the Mid-Day Studios regularly until 1956.

1948 Having lived for a few months at 72 Chorley Road, Swinton, moved to The Elms, Stalybridge Road, Mottram-in-Longdendale, Cheshire.

One-man exhibition at the Mid-Day Studios, Manchester.

Became a member of the London Group.

1950 Exhibited in *Painter's Progress* at the Whitechapel Art Gallery, London.

1951 Publication of *The Discovery of L. S. Lowry* by Maurice Collis (Alex Reid and Lefevre). Lowry's London gallery put up the money for this book, which was the first monograph.

Retrospective exhibition at Salford Art Gallery.

Exhibited in *British Painting 1925–50*, Arts Council touring exhibition.

Exhibited in *Two Lancashire Painters* (with Theodore Major) Arts Council North West Area Regional Exhibition.

1952 One-man show at Andras Kalman's Crane Gallery, Manchester (and 1955 and 1958). When Andras Kalman moved to London The Crane Kalman Gallery continued to hold regular shows of Lowry's work.

Retired on full pension from the Pall Mall Property Company. Lowry had risen to position of Chief Cashier and the firm had allowed him considerable freedom to pursue his artistic career.

Work acquired by the Museum of Modern Art, New York.

1953 Appointed an official artist at Coronation of Queen Elizabeth II.

Of this experience Lowry wrote to his friend David Carr: 'I did all right on the day last week. I fear I didn't get there as early as I ought to have done (six o'clock in the morning was the time they asked folk to be in their places and I would hate to tell you what time I did arrive). The weather was awful in the afternoon, not so terrible in the morning. I was perched in a stand in front of the Palace – a very good view – in fact it couldn't have been better. What I am going to paint I don't know. Some excellent incidents took place round about which fascinated me but not, I should imagine, what the Ministry of Works want, I am sorry to say. They would have pleased you I feel sure – one gentleman perched up so precariously at the back of one of the stands with a view of nothing as far as I could tell, would have made an excellent picture. He wouldn't come down for anyone, no not even the police. I didn't make any drawings at the time but went back the next morning and did a few, but, as I say, what I am going to paint I don't yet know, but it will sort itself out.'[13] The picture went to the British Embassy in Moscow.

1955 Elected Associate Member of Royal Academy of Arts.

Exhibited (with Josef Herman) at Wakefield Art Gallery.

1956 Awarded the Freedom of Mottram-in-Longdendale.

1957 BBC Television documentary *L. S. Lowry*, produced by John Read. Monty Bloom, a Manchester businessman, saw, by chance, the end of this film. Bloom was intrigued, subsequently met Lowry and became a friend and one of his most ardent collectors. He introduced Lowry to Wales and a fresh industrial landscape inspired a series of paintings.

1958 The Lowry Gallery (a permanent display of the artist's work) set up at Salford Art Gallery.

1959 Retrospective exhibition at Manchester City Art Gallery.

Exhibited in British Group Exhibition at Robert Osbourne Gallery, New York.

1960 Exhibition at Altrincham Art Gallery, and at Harrogate Festival of Visual Arts.

Work from the Revd. Geoffrey Bennett Collection exhibited at Middlesbrough Art Gallery (and Laing Art Gallery, Newcastle, 1961).

1961 Made Honorary LL.D., University of Manchester.

Exhibition at opening of Monks Hall Museum, Eccles.

Exhibition at Swinton and Pendlebury Public Library (and 1964).

1962 Elected full member of the Royal Academy of Arts.

Retrospective at the Graves Art Gallery, Sheffield.

1964 *A Tribute to L. S. Lowry* exhibition at Monks Hall Museum, Eccles (25 contemporary artists including Henry Moore, Victor Pasmore and Ivon Hitchens sent works marking Lowry's 77th birthday).

Catalogue included an appreciation by Sir Kenneth Clark: 'posterity will pay attention to him . . . because he is a genuine artist, who first responds to what he sees, irrespective of what it represents, and then broods sympathetically on the result.'

Hallé Concert Society, Manchester, 77th Birthday Concert.

Exhibition at Stone Gallery, Newcastle-upon-Tyne (paintings from the Monty Bloom Collection). Lowry frequently visited the Northeast during the last part of his life, staying at the Seaburn Hotel, Sunderland. The Marshalls, who ran the Stone Gallery in Newcastle, became friends.

Included in *The Englishness of English Painting*, Robert Osbourne Gallery, New York.

He described his life at this period: 'I usually paint each morning. I get up whenever I feel like it and I work till about lunch-time. No, I never know what I'm going to do each morning. I like to have a dozen paintings in the studio, all going strong, and I like to work on whichever takes my fancy. At lunch-time I take the bus into Manchester – unless I'm away. I do that every day. I get my lunch anywhere – I'm very fond of tomato soup. After lunch I go off walking to the places I like – down the Oldham Road, I never grow tired of that. I walk and walk and I suppose I'm taking it all in. You know, I get

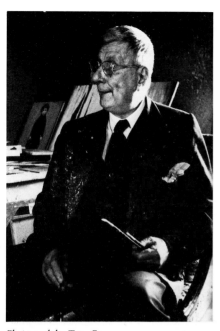

Photograph by Tony Evans

Photograph by Tony Evans

so wrapped up, watching people, that sometimes I get into trouble – I've even been accused of following them. Of course, I am in a way – but still. Sometimes I can remember the details I see but I make a lot of sketches – as many as a hundred if I need them. While I'm out, walking or sketching, somebody comes into the house and cleans up for me – and when I get back to Mottram, I'm ready for tea; high tea, the last meal of the day. Then I start painting again. And I go on a long time. In some queer way I seem to brighten up about midnight'.[14] 'Often I paint solidly right on into the early hours of the morning; often until two or three o'clock. Light doesn't bother me you see, except for my finishing touches which must be done in daylight. I love working at night, when everything is still and peaceful, and drowned in silence. Often I play the gramophone at night; music is very important to me. Italian opera is my special passion, and Bellini and Donizetti are my favourite composers. I am particularly fond of all Bellini's operas and the Lucia di Lammermoor of Donizetti. Often, I play the same record over and over again, all through the night . . . I love monotony you see, as well as music.'[15]

1965 Awarded the Freedom of the City of Salford.

Granada Television documentary *Mr Lowry*, produced by Leslie Woodhead.

1966 Voted 'Man of the Year' by Manchester Junior Chamber of Commerce.

Exhibition at Monks Hall, Eccles (pictures from Monty Bloom family collection).

Arts Council touring exhibition, culminating in showing at the Tate Gallery. Reviews of the exhibition included the following by the painter Francis Hoyland, now Senior Lecturer at Camberwell School of Art:

'Any painter who works away from his subject is forced to develop a series of devices in order to get his picture to make sense – to open up the space and to control the surface – and, having made up his mind to present straightforward images of the industrial north, Lowry made his devices work in the interests of clarity. The clearest two colours in combination are black and white, like a newspaper, and white runs right through these pictures to be contrasted with the black outlines of the forms. This is a fairly obvious thing to do, but very few artists can

cope with the problems it raises. These problems centre around the other colours, since they tend to be made redundant by the presence of the strongest possible contrast in other parts of the picture. Lowry gets round this by treating his various tones with utter ruthlessness: in the middle of a shadowed wall he will introduce a strong local colour that could not appear in nature; and brilliant reds crop up in the middle distance as well as in the foreground. These distortions are made in the interests of pictorial unity, and they have pictorial truth.

'Lowry has an immaculate sense of tone, but not the sort of tone that is found for instance, in Corot. His mastery is shown in his ability to pitch a whole painting in terms of contrasts which tend to follow a definite scheme, with a dark strip in the foreground and a progressive lightening farther up the picture, but almost pure black areas wherever the imagery demands special emphasis. As the forms tend to be piled on top of each other, their recession largely depends on tone. But certain spatial devices do occur. Often, for instance, an elliptical shape opens up behind dark foreground planes: this device is epitomised in the *Lake Landscape* of 1950. Lowry has also a habit of preserving the picture plane with one surface of a building while opening it up with another, thus arriving at a sort of isometric projection. When this effect is combined with his usual high viewpoint, as it is in his painting of *VE Day*, it can give rise to an intriguing spatial complexity. Lowry's figures are simplified in order to go with the buildings, but they are sympathetically observed, and the casual scattering of these figures can suddenly accrue into a crowd round a tipster or a speaker at a public meeting, with great emotional effect.

'The overall imagery of the exhibition is sombre, the scale of man is small, and Lowry's pictures attain complete peace only when man is absent altogether, as in the seascapes. My chief memory is of the sheer integrity of Lowry's painting itself – his grounds and skies are marvellous.'

'Lowry', *Spectator*,
9 December 1966

1967 GPO issued a stamp showing an industrial scene by Lowry.

Exhibition at the Stone Gallery, Newcastle-upon-Tyne.

Exhibition at the Magdalene Street Gallery, Cambridge.

Exhibition at the Playhouse, Nottingham.

Exhibition at the Crane Kalman Gallery, London.

Permanent exhibition at Salford Art Gallery enlarged.

1968 Exhibition at Mottram-in-Longdendale.

Tyne Tees Television documentary, *Mister Lowry*, produced by Robert Tyrell.

1970 Exhibition at the new Swinton Art Gallery.

The Drawings of L. S. Lowry 1923–65, Tib Lane Gallery, Manchester.

Exhibition at Norwich Castle Museum (pictures from Salford Art Gallery Collection).

Works included in Arts Council Touring Exhibition *Decade* 1920–30.

1971 Exhibition in Belfast organised by the Northern Ireland Arts Council.

Exhibition at the Haworth Art Gallery, Accrington.

Offered Companion of Honour by Edward Heath. This was not the first or the last time that Lowry was offered official honours and on this occasion he wrote: 'I have at all times tried to paint to the best of my ability and I would only hope that any remembrance people may have of me when I am gone may be based on my work rather than on any decoration I may have collected on the journey.'[16]

1972 Exhibition at the Turnpike Gallery, Leigh Public Library.

Exhibition at the Hamet Gallery, London (Monty Bloom Collection).

1973 Exhibition at the Walker Art Gallery, Liverpool.

1974 Exhibition at Nottingham University Art Gallery.

Exhibition at Whitworth Art Gallery, Manchester (Ives Collection).

1975 Honorary Degree of D.Lit., the University of Salford.

Honorary Degree of D.Lit., the University of Liverpool.

1976 Died 23 February, Woods Hospital, Glossop, after an attack of pneumonia. He had said: 'You know, I've never been able to get used to the fact that I'm alive! The whole thing frightens me. It's been like that from my earliest days. It's too big you know – I mean life, sir. It's like Rembrandt – he's too big, isn't he? That's why I can't stand him – he's like life; you can't grasp him. I detest Rembrandt for that reason. Oh yes, the whole thing frightens me. It's all too big. Can you see what I mean, sir? Now Boudin I like; he's a lovely artist – a small view – I can grasp him: you can see what he's up to. But is he a great painter? Do you think he is? And what is greatness anyway? What about me? Will I live?'

September–November: Large retrospective exhibition at the Royal Academy of Arts. Reviews included the following comments:

'The Academy exhibition shows a painter of individual vision whose style ranged from careful early academic drawings, through Gross-like line caricatures of the men of the twenties to Impressionist seascapes and unpleasantly expressionist portraits ... he could expand his range convincingly into single figures that were funny or bleak or satirical. It was a modest comedy of manners in which the actors were never specific, a kind of Manchester version of the Pirandello characters he admired on stage ... stock characters not people ... their gestures and not their features were of interest. The same goes for his bleakest scenes, the gaunt black ship on the river was the archetype of a ship, a symbol perhaps, but not an allegory. Lakes and seascapes were desolate in a generalised way, as much in the mind as the eye.'

Caroline Tisdall,
'Sticking Point', *The Guardian*,
4 September 1976

'Lowry's work ... might be seen as the chronicling of a society produced by the upheavals of the industrial revolution ... the loneliness, dereliction, and also the melancholy poetry and dense texture of life of the northern English cities which had been shaped by that revolution. Yet if one compares Lowry's paintings with the novels and essays of D. H. Lawrence which depict the effect of industrialization on Nottinghamshire – or the whole tradition of late nineteenth- and early twentieth-century English

fiction which took as its subject matter the effect of this on England and the English, Lowry's portrayal of this world seems a minor and repetitive one.'

Paul Overy,
'Lowry the Chronicler', *The Times*,
7 September 1976

'Handled with a blunt gaucherie close enough to Sunday painting to convince spectators that they could do as well, given a little practice, and redolent of a man who wanted to communicate in the most straightforward manner imaginable, the 334 items in this exhibition mount an impressive plea for popular, totally accessible art ...

'Throughout the 1920s, Lowry can be seen removing his work increasingly from the plight of the depression, mass unemployment and the General Strike. The citizens who scurry through his paintings are notable for their sense of isolation, certainly, and they receive scant comfort from the unseeing windows of the buildings which dominate and control their manic movements. But the overall context is that of a toy-town, a picturesque stage where Lorwy can dramatise his own private loneliness and draw reassurance from the childlike dream-world which his imagination inhabited ...

'Lowry's strength as an artist lies in his ability to construct an artificial tableau which is at the same time rooted in an intense love for the geometry of back-to-back terraces, the attenuated silhouettes of chimneys, the blackened and immovable bulk of squat warehouses ...

'But the most negative side of Lowry's work is its ... nostalgia. Locked in a 1920s time-capsule which bears little relation to the present-day nightmare of soulless concrete to be found as much in Manchester as its equivalents elsewhere, his art provides a springboard for sentimentality.'

Richard Cork,
'Lowry and the toy-town illusion', *Evening Standard*,
9 September 1976

'Little has been said to date about the formal qualities of Lowry's paintings and drawings, although these are as remarkable as the compositions of Seurat ... The central emphasis is often achieved by a road leading into the distance towards a centrally placed building, a gateway, a tree, planted in the middle of a square, or a

group of people where the tallest is surrounded by others gradually decreasing in size, rather like a human hill. The figures in processions, going to work, pouring out of factories, attending fairs and football matches, are like surging streams of energy in the pale streets and against the solid buildings, animating a formal and static composition . . . among the most moving, the most complete and expressive, are his latest works: the grotesque figures and personages which Ionesco and Beckett might easily recognise as their own creations . . .'

Jasia Reichardt,
'Manhole', *New Statesman*,
10 September 1976

'So Lowry was a Sunday painter after all . . . it is revealed that from 1904 until his retirement

at sixty-five in 1952 he worked a nine-to-five day in an office. Until now, of course, he and his publicists have made no mention of this damaging fact . . .

'His pictures, even with the help of the myth, looked amateurish in technique. There is no subtlety in his use of paint at all, and he constantly appears to be striving for illusions of depth which he simply has not the expertise to attain . . .

'They are of no symbolic or more generalised interest, as is to be expected from such a profoundly parochial man, but because they are dispassionate, observant and set in unromanticised industrial towns they transcend the concerns of most part-time painters. They may even remain of some topographical interest and they are

entertaining, which is why they will remain popular.'

John McEwen, 'Storyteller', *Spectator*,
18 September 1976

'This exhibition convinces me that Lowry is a genius and for two reasons. One is simply the technical base from which he worked, the innovatory skill of his techniques – note for instance the ways in which small flecks of red, a ubiquitous device sometimes signifying nothing except punctuation, sometimes a piece of clothing, a lamp-post, a sign, subtly lead the eye round a complex composition of pervasive rhythms . . . The other is the tenacity with which he pursued his uncomfortable visions, and in doing so changed our apprehensions of certain kinds of emotional realities.

'What is even more mysterious is his popularity. His paintings are not quaint or picturesque. They attest to a brutal truth. And yet we love them.'

Marina Vaizey,
'Lowry's guide to survival', *The Sunday Times*
5 September 1976

Exhibition at the Museum and Art Gallery, Wigan.

1977 *A pre-Raphaelite Passion*, Manchester City Art Gallery (23 paintings and drawings from Lowry's collection – 15 by Rossetti, one by Ford Madox Brown). Also works by Lowry in collection of Manchester City Art Gallery.

Expanded permanent exhibition at Salford Art Gallery, including 67 works from the artist's estate.

Exhibitions at Mottram-in-Longdendale and Stalybridge Art Gallery.

BBC Television documentary *'I'm just a simple man'*, produced by John Read.

1979–1985 Exhibitions at Kendal, Sheffield, Stockport, Leicester, Stalybridge and Swansea, University College, the Taliesin Centre for the Arts (drawings).

1987 *Mr Lowry at Home* – Manchester City Art Gallery. Reconstruction of two rooms of Lowry's home in Mottram-in-Longdendale.

October: Exhibition at Crane Kalman Gallery, London.

October: *The Centenary Exhibition*, Salford Art Gallery and Centenary Festival, Salford.

Photograph by Tony Evans

NOTES

INTRODUCTION

1. *Mister Lowry*, Tyne Tees Television, quoted in Shelley Rohde, *A Private View of L. S. Lowry* (see Bibliography).

THE PAINTINGS AND DRAWINGS

All quotations are from conversations and interviews with the artist or from his correspondence.

2. Maurice Collis, *The Discovery of L. S. Lowry* (see Bibliography).

3. Taped conversation with Gerald B. Cotton and Frank Mullineux, quoted in Rohde.

4. Letter to Harold Timperley, 14 June 1929, quoted in Rohde.

5. Collis.

6. *Ibid.*

7. Letter to David Carr, 16 August 1948, quoted in Rohde.

8. Cotton/Mullineux tapes, quoted in Rohde.

9. Allen Andrews, *The Life of L. S. Lowry* (see Bibliography).

10. Taped conversation with Monty Bloom, quoted in Rohde.

11. 'Portrait of the artist, Mr Lowry', John Heilpern, *The Observer* 9 November 1975, quoted in Rohde.

12. Noël Barber, *Conversations with Painters* (see Bibliography).

13. Andrews.

14. Rohde.

15. *Ibid.*

16. Barber.

17. Cotton/Mullineux tapes, quoted in Rohde.

18. Andrews.

19. Mervyn Levy, *L. S. Lowry* (see Bibliography).

20. Collis.

21. Andrews.

22. Levy

23. Andrews.

24. *Ibid.*

25. Letter to David Carr, 16 August 1948, quoted in Rohde.

26. *Mister Lowry*, Tyne Tees Television, quoted in Rohde.

27. 'My Lonely Life' by L. S. Lowry, interview with Edwin Mullins, *Sunday Telegraph*, 20 November 1966 (reprinted in Leber and Sandling, *L. S. Lowry*, see Bibliography).

28. Levy.

29. Levy.

30. Conversation with Monty Bloom.

31. Mullins interview.

32. Andrews.

33. Letter to David Carr, 13 November 1948, quoted in Rohde.

34. *Mister Lowry*, Tyne Tees Television, quoted in Rohde.

35. Taped conversation with Professor Hugh Maitland, winter 1970, quoted in Rohde.

36. *Mr Lowry*, Granada Television, quoted in Rohde.

37. *Mister Lowry*, Tyne Tees Television, quoted in Rohde.

38. Taped conversation with Monty Bloom, quoted in Rohde.

39. Quoted in a letter from L. A. Ives to Caroline Collier, 14 September 1987.

40. *Ibid.*

41. Cotton/Mullineux tapes, quoted in Rohde.

CHRONOLOGY

Compiled by Caroline Collier

1. Andrews.

2. Maitland tapes quoted in Rohde.

3. Andrews.

4. *Ibid.*

5. *Ibid.*

6. *Ibid.*

7. *Ibid.*

8. Rohde.

9. Mullins interview.

10. Reviews of this and of the 1945 exhibition are discussed in detail in Collis.

11. Rohde.

12. Collis.

13. Letter to David Carr, 8 June 1953, quoted in Rohde.

14. Barber.

15. Levy.

16. Rohde.

CATALOGUE

Works are listed in chronological order and measurements are given in centimetres, height before width.

1 Still Life 1906
oil on canvas board
23.5 × 33.5cm
CITY OF SALFORD ART GALLERY
Ill. p.25

2 Clifton Junction – Morning 1910
oil on board
20.2 × 34.8cm
CITY OF SALFORD ART GALLERY
Ill. p.26

3 Clifton Junction – Evening 1910
oil on board
19 × 35.5cm
CITY OF SALFORD ART GALLERY
Ill. p.26

4 Boy in a Schoolcap 1912
pencil and white chalk on paper
42.5 × 24.5cm
CITY OF SALFORD ART GALLERY
Ill. p.66

5 Head of a Bald Man c.1913–14
oil on panel
28.7 × 18.2cm
CITY OF SALFORD ART GALLERY
Ill. p.65

6 Country Lane 1914
oil on panel
23.6 × 15.6cm
CITY OF SALFORD ART GALLERY
Ill. p.58

7 Study of a Woman's Head 1914
pencil on paper
44.1 × 35.5cm
CITY OF SALFORD ART GALLERY
Ill. p.24

8 Fishing Boats at Lytham 1915
pastel on paper
38 × 47cm
PRIVATE COLLECTION
Ill. p.42

9 Coming from the Mill 1917–18
pastel on paper
43.7 × 56.1cm
CITY OF SALFORD ART GALLERY
Ill. p.30

10 The Funeral 1920
oil on board
33 × 45cm
MARTIN D. H. BLOOM
Ill. p.55

11 Office Head c.1920
pen and ink on paper
20 × 20.8cm
CITY OF SALFORD ART GALLERY
Ill. p.73

12 Office Head c.1920
pen and ink on paper
20.5 × 20.7cm
CITY OF SALFORD ART GALLERY
Ill. p.73

13 Office Head c.1920
pen and ink on paper
21.3 × 20.7cm
CITY OF SALFORD ART GALLERY
Ill. p.73

14 Office Head c.1920
pencil on paper
21 × 20cm
CITY OF SALFORD ART GALLERY
Ill. p.73

15 The Spinner's Arms c.1920
pencil on paper
27.2 × 20.2cm
CITY OF SALFORD ART GALLERY
Ill. p.56

16 Sudden Illness 1920
oil on board
25 × 49cm
MARTIN D. H. BLOOM
Ill. p.53

17 The Lodging House 1921
pastel on paper
50.1 × 32.6cm
CITY OF SALFORD ART GALLERY
Ill. p.27

18 Whit Week Procession at Swinton 1921
oil on board
27 × 45cm
PRIVATE COLLECTION
Ill. p.44

19 Interior Discord 1922
pencil on paper
27.1 × 20.9cm
SUNDERLAND MUSEUM AND ART GALLERY
(TYNE AND WEAR MUSEUMS SERVICE)
Ill. p.68

20 Blackpool Tower 1923
pencil and pastel on grey paper
11 × 16cm
PRIVATE COLLECTION

21 View from a Window of the Royal Technical College, Salford 1924
pencil on paper
54.4 × 37.5cm
CITY OF SALFORD ART GALLERY
Ill. p.54

22 Bandstand, Peel Park, Salford 1925
pencil on paper
36.7 × 54.6cm
CITY OF SALFORD ART GALLERY
Ill. p.46

23 Bridge with Figures over Colliery Railway c.1925
pencil on paper
37 × 55cm
CITY OF SALFORD ART GALLERY
Ill. p.64

24 Lancashire Street Scene with Figures 1925
pencil on paper
35.7 × 25.5cm
WHITWORTH ART GALLERY, UNIVERSITY OF MANCHESTER
Ill. p.57

25 Self-Portrait 1925
oil on board
57.2 × 47.2cm
CITY OF SALFORD ART GALLERY
Ill. p.24

26 The Mid-day Special 1926
pencil on paper
38.4 × 27.8cm
CITY OF SALFORD ART GALLERY
Ill. p.52

27 Peel Park, Salford 1927
oil on board
35 × 50cm
CITY OF SALFORD ART GALLERY
Ill. p.10

28 **A Street Scene – St Simon's Church** 1928
oil on board
43.8 × 38cm
CITY OF SALFORD ART GALLERY
Ill. p.28

29 **Coming from the Mill** 1930
oil on canvas
42 × 52cm
CITY OF SALFORD ART GALLERY
Ill. p.31

30 **St Augustine's Church, Pendlebury** 1930
pencil on paper
35.1 × 26cm
CITY OF SALFORD ART GALLERY
Ill. p.63

31 **The Bandstand, Peel Park, Salford** 1931
oil on canvas
43.2 × 62.2cm
YORK CITY ART GALLERY
Ill. p.47

32 **The Empty House** 1934
oil on plywood
43.2 × 51.3cm
STOKE-ON-TRENT CITY MUSEUM AND ART
GALLERY
Ill. p.62

33 **Street Scene** 1935
oil on canvas
43 × 53cm
THE ATKINSON ART GALLERY, SOUTHPORT
METROPOLITAN BOROUGH OF SEFTON
(LIBRARIES AND ARTS SERVICES)
Ill. p.51

34 **Head of a Man** 1938
oil on canvas
50.7 × 41cm
CITY OF SALFORD ART GALLERY
Ill. p.32

35 **Outside the Lodging House** 1938
pencil on white paper
38 × 28.4cm
CITY OF MANCHESTER ART GALLERIES
Ill. p.56

36 **St John's Church, Manchester** 1938
oil on canvas
30 × 29cm
CITY OF MANCHESTER ART GALLERIES
Ill. p.59

37 **Market Scene, Northern Town** 1939
oil on canvas
45.7 × 61.1cm
CITY OF SALFORD ART GALLERY
Ill. p.51

38 **The Bedroom, Pendlebury** 1940
oil on canvas
35.8 × 51.2cm
CITY OF SALFORD ART GALLERY
Ill. p.36

39 **An Old Lady** 1942
oil on canvas
50 × 42.5cm
MAITLAND COLLECTION
Ill. p.71

40 **July, the Seaside** 1943
oil on canvas
66.7 × 92.7cm
ARTS COUNCIL COLLECTION
Ill. p.39

41 **Deserted Mill** 1945
oil on canvas
38 × 54cm
PRIVATE COLLECTION

42 **Flowers in a Window** 1945
pencil on paper
25 × 33.7cm
MAITLAND COLLECTION
Ill. p.63

43 **VE Day** 1945
oil on canvas
78.7 × 101.6cm
GLASGOW ART GALLERY AND MUSEUM
Ill. p.48

44 **Good Friday, Daisy Nook** 1946
oil on canvas
72.5 × 91.5cm
GOVERNMENT ART COLLECTION
Ill. p.49

45 **The Cripples** 1949
oil on canvas
76.3 × 101.8cm
CITY OF SALFORD ART GALLERY
Ill. p.72

46 **Father and Sons** 1950
oil on canvas
75 × 100cm
MARTIN D. H. BLOOM
Ill. p.69

47 **Lake Landscape** 1950
oil on canvas
71 × 91.5cm
WHITWORTH ART GALLERY, UNIVERSITY OF
MANCHESTER
Ill. p.37

48 **Seascape** 1952
oil on canvas
39.5 × 49.3cm
CITY OF SALFORD ART GALLERY
Ill. p.61

49 **Courting** 1955
coloured pencil and crayon on paper
25 × 35cm
PRIVATE COLLECTION
Ill. p.70

50 **Man Lying on a Wall** 1957
oil on canvas
40.7 × 50.9cm
CITY OF SALFORD ART GALLERY
Ill. p.64

51 **Portrait of Ann** 1957
oil on board
38.6 × 33.3cm
CITY OF SALFORD ART GALLERY
Ill. p.34

52 **Woman with a Beard** 1957
oil on canvas
59 × 49cm
MARTIN D. H. BLOOM
Ill. p.67

53 **Ebbw Vale** 1960
oil on canvas
114 × 153cm
HERBERT ART GALLERY AND MUSEUM,
COVENTRY
Ill. p.45

54 **Head of a Boy** c.1960
oil on board
21.5 × 21cm
CITY OF SALFORD ART GALLERY
Ill. p.71

55 **Maryport** 1960
oil on canvas
47 × 59cm
MARTIN D. H. BLOOM
Ill. p.60

56 **Over the Hill** 1961
pencil on paper
34.5 × 25.1cm
CITY OF SALFORD ART GALLERY
Ill. p.64

57 **Father Going Home** 1962
oil on canvas
37 × 25cm
MARTIN D. H. BLOOM
Ill. p.84

58 **Man Drinking Water** 1962
oil on board
37 × 31cm
MARTIN D. H. BLOOM
Ill. p.75

59 **Spotted Dog** 1963
black ballpoint pen on paper
17.8 × 12.8cm
CITY OF SALFORD ART GALLERY
Ill. p.83

60 **A Court, Manchester** 1964
oil on canvas
39.5 × 29.5cm
COLLECTION OF L. A. AND D. C. IVES
Ill. p.50

61 **The Family** 1964
pencil on paper
20 × 12.7cm
COLLECTION OF L. A. AND D. C. IVES
Ill. p.82

62 **Two Men on a Park Bench** 1964
oil on canvas
39 × 49cm
MARTIN D. H. BLOOM
Ill. p.74

63 **A Beggar** 1965
oil on board
19 × 11.5cm
CITY OF SALFORD ART GALLERY
Ill. p.40

64 **Pantomime Cat** c.1965
pencil on paper
13.7 × 17.8cm
CITY OF SALFORD ART GALLERY
Ill. p.80

65 **Woman in Black** 1965
pencil on paper
34.7 × 25.4cm
CITY OF SALFORD ART GALLERY
Ill. p.78

66 **Minimal Drawing of a Girl** 1966
pencil on paper
21.7 × 15.5cm
CITY OF SALFORD ART GALLERY
Ill. p.83

67 **Family Group** 1967
pencil on paper
41.7 × 29.7cm
COLLECTION OF L. A. AND D. C. IVES
Ill. p.79

68 **Girl with Red Scarf and Black Trousers**
1967
oil on canvas
26.5 × 19.5cm
COLLECTION OF L. A. AND D. C. IVES
Ill. p.80

69 **Three Figures (Mother and Sons)** 1967
oil on canvas
50 × 40cm
MARTIN D. H. BLOOM
Ill. p.68

70 **Waiting for the Tide, South Shields** 1967
oil on canvas
15.1 × 30.5cm
CITY OF SALFORD ART GALLERY
Ill. p.38

71 **The Rock** 1968
pencil on paper
41.7 × 29.6cm
CITY OF SALFORD ART GALLERY
Ill. p.63

72 **A Game of Marbles** 1970
pencil on paper
25.2 × 35.3cm
CITY OF SALFORD ART GALLERY
Ill. p.77

73 **In the Sea** c.1970
pencil on paper
29.6 × 41.9cm
CITY OF SALFORD ART GALLERY
Ill. p.77

74 **Meeting Friends** c.1970
pencil on paper
30.6 × 22.7cm
CITY OF SALFORD ART GALLERY
Ill. p.76

75 **The Shark** 1970
pencil and black ballpoint pen on
paper
25.4 × 35.6cm
CITY OF SALFORD ART GALLERY
Ill. p.83

76 **The Tramp, St Peter's Square** 1971
pencil on paper
41 × 29.5cm
COLLECTION OF L. A. D. C. IVES
Ill. p.75

77 **Girl with a Bow** c.1973
pencil on paper
33 × 21.5cm
CITY OF SALFORD ART GALLERY
Ill. p.81

78 **Girl with a Bow** c.1973
pencil on paper
29.8 × 21cm
CITY OF SALFORD ART GALLERY

79 **Girl with Bows** c.1973
pencil on paper
28.2 × 22.3cm
CITY OF SALFORD ART GALLERY
Ill. p.66

BIBLIOGRAPHY

ANDREWS, ALLEN *The Life of L. S. Lowry*, Jupiter Books, 1977

BARBER, NOËL *Conversations with Painters*, Collins, 1964

COLLIS, MAURICE *The Discovery of L. S. Lowry*, Alex Reid and Lefevre, 1951

LEBER, MICHAEL and SANDLING, JUDITH *L. S. Lowry* (including catalogue raisonné of works in public collections), Phaidon, 1987

LEVY, MERVYN *L. S. Lowry* (Painters of Today), Studio Books, 1961

LEVY, MERVYN *The Drawings of L. S. Lowry*, Cory, Adams and Mackay, 1963

LEVY, MERVYN *The Paintings of L. S. Lowry*, Jupiter Books, 1978

LEVY, MERVYN *The Drawings of L. S. Lowry, Public & Private*, Jupiter Books, 1978

MARSHALL, TILLEY *Life with Lowry*, Hutchinson, 1981

ROHDE, SHELLEY *A Private View of L. S. Lowry*, Collins, 1979 (revised edition in paperback, Methuen, 1987)

SPALDING, JULIAN *Lowry*, Phaidon, 1979

L. S. Lowry — exhibition catalogue (including introduction by Edwin Mullins), Arts Council, 1966

L. S. Lowry — exhibition catalogue (including introduction by Mervyn Levy and a number of tributes), Royal Academy of Arts, 1976

Laurence Stephen Lowry, The Salford Collection, Salford Cultural Services Department, 1977

LENDERS

Numbers refer to catalogue entries.

Martin D. H. Bloom 10, 16, 46, 52, 55, 57, 58, 62, 69
Collection of L.A. and D.C. Ives 60, 61, 67, 68, 76
Maitland Collection 39, 42
Private Collections 8, 18, 20, 41, 49

Coventry, Herbert Art Gallery and Museum 53
Glasgow Art Gallery and Museum 43
LONDON
Arts Council Collection 40
Government Art Collection 44
MANCHESTER
City Art Galleries 35, 36
Whitworth Art Gallery 24, 47
Salford City Art Gallery 1, 2, 3, 4, 5, 6, 7, 9, 11, 12, 13, 14, 15, 17, 21, 22, 23, 25, 26, 27, 28, 29, 30, 34, 37, 38, 45, 48, 50, 51, 54, 56, 59, 63, 64, 65, 66, 70, 71, 72, 73, 74, 75, 77, 78, 79
Southport, Atkinson Art Gallery 33
Stoke-on-Trent City Museum and Art Gallery 32
Sunderland Museum and Art Gallery 19
York City Art Gallery 31

PHOTOGRAPHIC CREDITS

We are grateful to all those who have supplied photographs of works in their collections. In addition to the acknowledgements given in captions we should like to thank the following:
Plate no.13; Marlborough Fine Art (London) Ltd.
Plate no.28: The Bridgeman Art Library.
Plate no.33: The Medici Society.
Certain photographs have been taken for this book by John Cass and Derek Seddon.